Decorative French Ironwork Designs

Louis Blanc

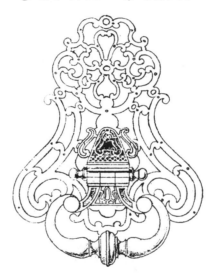

Dover Publications, Inc.
Mineola, New York

Bibliographical Note

This Dover edition, first published in 1999, is a republication of the work originally titled *La Ferronerie à Bordeaux,* published privately in Paris, n.d. A new Publisher's Note has been specially prepared for this edition.

DOVER *Pictorial Archive* SERIES

This book belongs to the Dover Pictorial Archive Series. You may use the designs and illustrations for graphics and crafts applications, free and without special permission, provided that you include no more than ten in the same publication or project. (For permission for additional use, please write to Permissions Department, Dover Publications, Inc., 31 East 2nd Street, Mineola, N.Y. 11501.)

However, republication or reproduction of any illustration by any other graphic service, whether it be in a book or in any other design resource, is strictly prohibited.

Library of Congress Cataloging-in-Publication Data

Blanc, Louis, 1811–1882.
 [Ferronerie à Bordeaux. English]
 Decorative French ironwork designs.
 p. cm — (Dover pictorial archive series)
 A republication of the work originally titled *La ferronerie à Bordeaux,* published privately in Paris, n.d.
 ISBN 0-486-40487-0 (pbk.)
 1. Ironwork—France—Bordeaux—History—19th century—Themes, motives. I. Series.
NK8249.B67B6313 1999
739.4'744—dc21 99–19600
 CIP

Manufactured in the United States of America
Dover Publications, Inc., 31 East 2nd Street, Mineola, N.Y. 11501

PUBLISHER'S NOTE

Decorative ironwork, or *ferronnerie,* is a time-honored art in France that dates back to the Middle Ages. For centuries fine and elaborate wrought iron grilles, gates, door knockers, and balcony and stair railings were essential features in the best French buildings, from churches to chateaux. The city of Bordeaux, first known as a center for the production of arms (knives and swords), turned to the making of domestic items during peacetime and eventually became best known for the multitude of outstanding wrought iron works proudly displayed on the buildings of the city itself.

Architect Louis Blanc was so taken with these architectural embellishments that he took to sketching them at random. By the 1920s his pastime had yielded so many renderings—over 1500 in all—that he decided to publish a volume of them, privately, for the benefit of others who admire and study this art. His preface expressed the hope that this collection, *La Ferronnerie a Bordeaux,* would serve "architects, decorators, and metalworkers who would like to immerse themselves in the true source of the ironworker's art . . . [as well as] friends of this magnificent city, and all those who admire and appreciate the beautiful things of past eras."

This edition includes all the illustrations that originally appeared in Blanc's book. Each carries an identification of the address where the original architectural feature was found. In addition, Blanc was careful to capture works drawn from the full history of Bordeaux *ferronnerie;* works of all periods are covered. The drawings fall into three sections: "Balcony Railings and Imposts" (pp. 1–43), "Gates, Grilles, and Door Knockers" (pp. 44–72), and "Stair Railings" (pp. 73–91). Together, they represent a wealth of examples of the very best in French decorative ironwork.

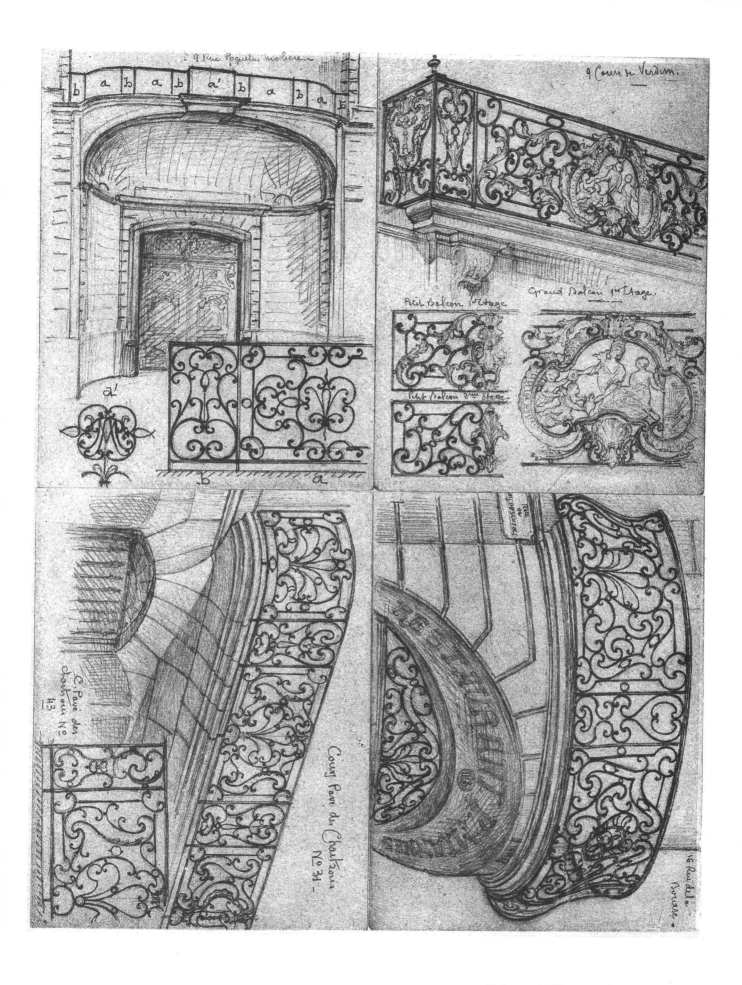

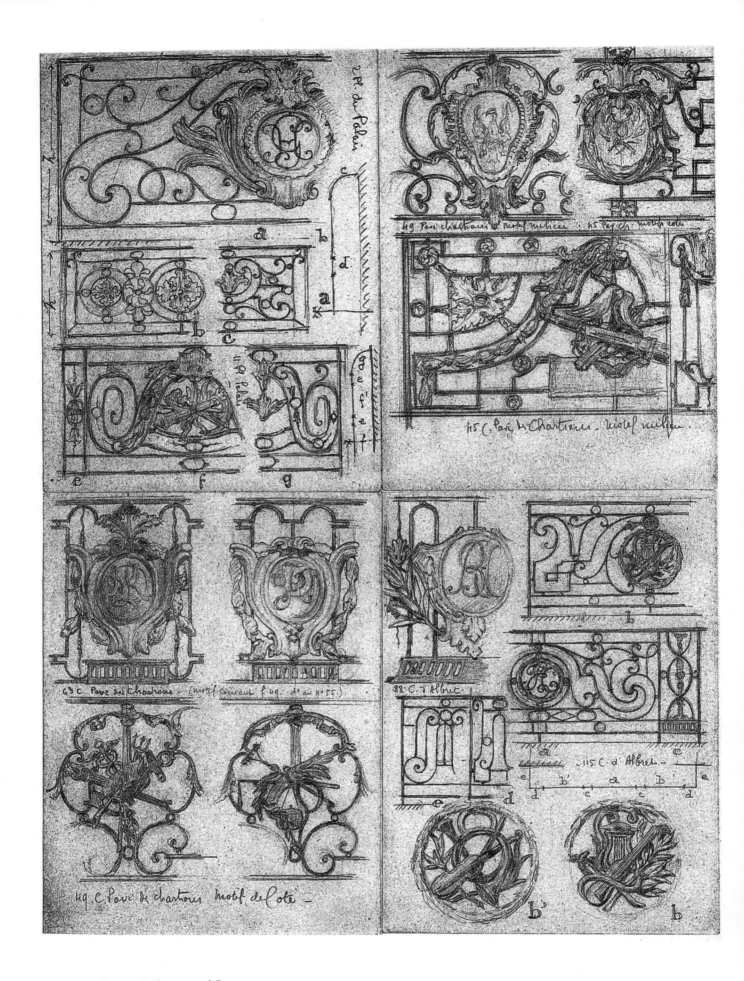

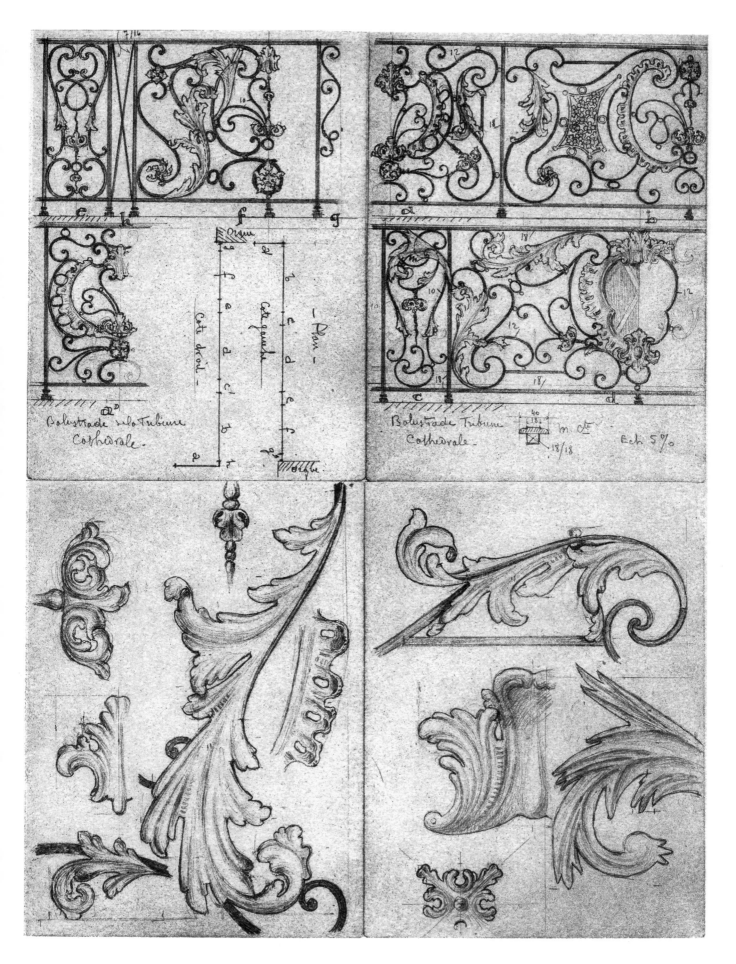

Balustrade sur la Tribune
Cathédrale.

Balustrade Tribune
Cathédrale.

Echelle 5%

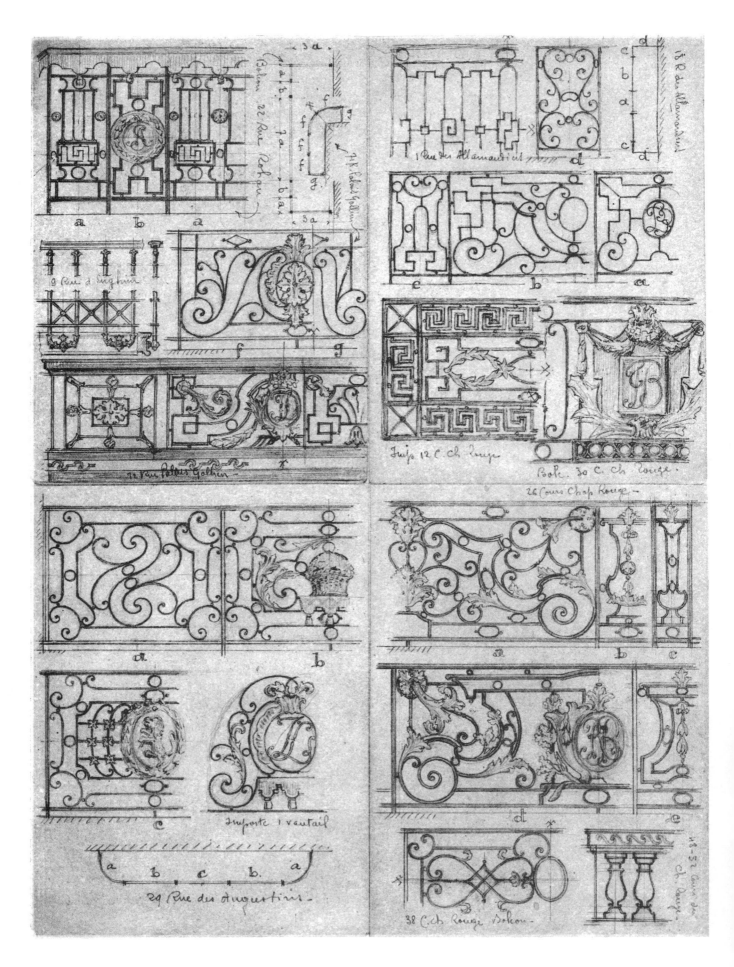

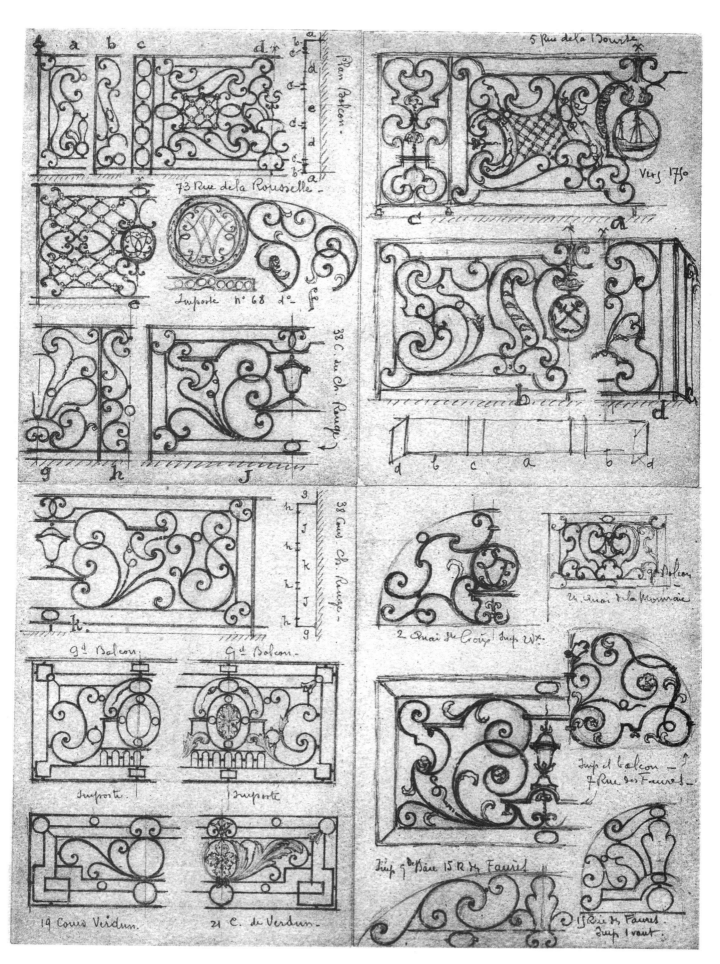

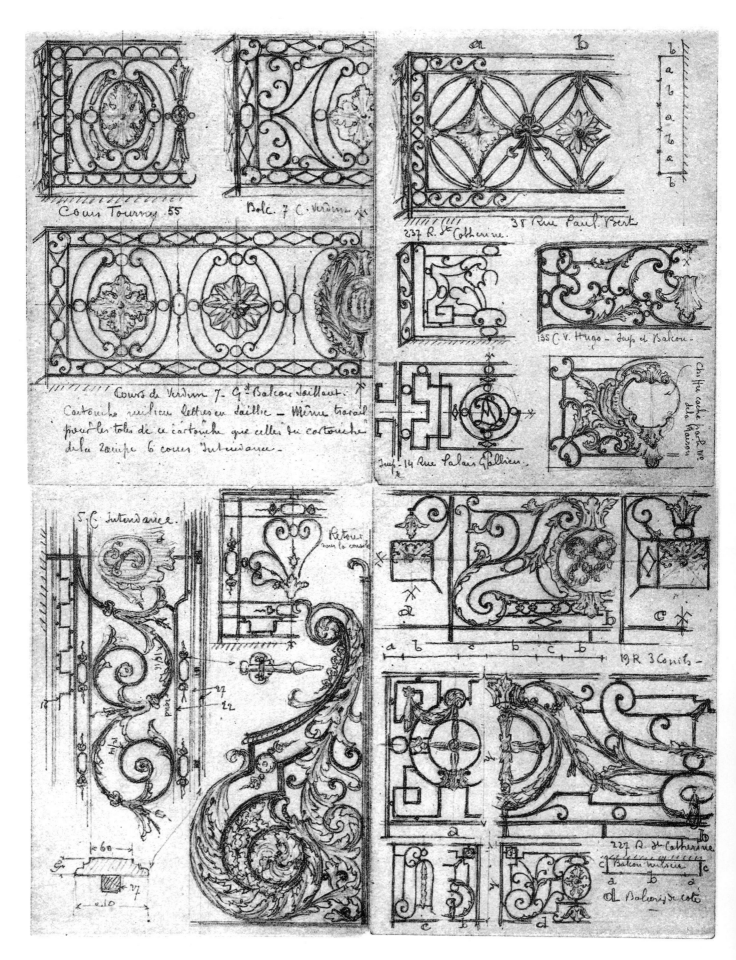

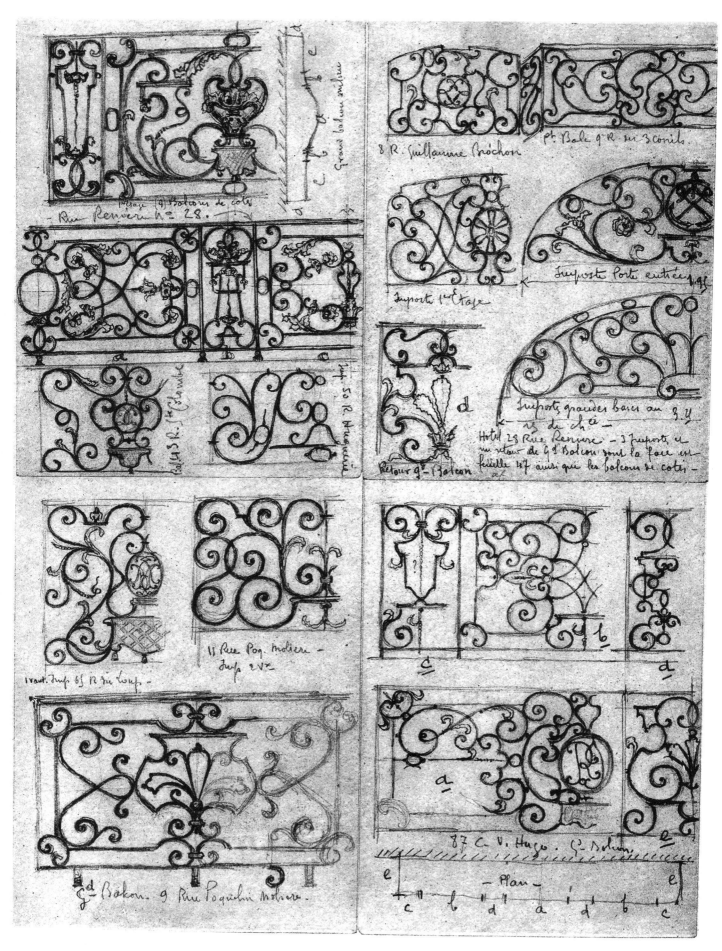

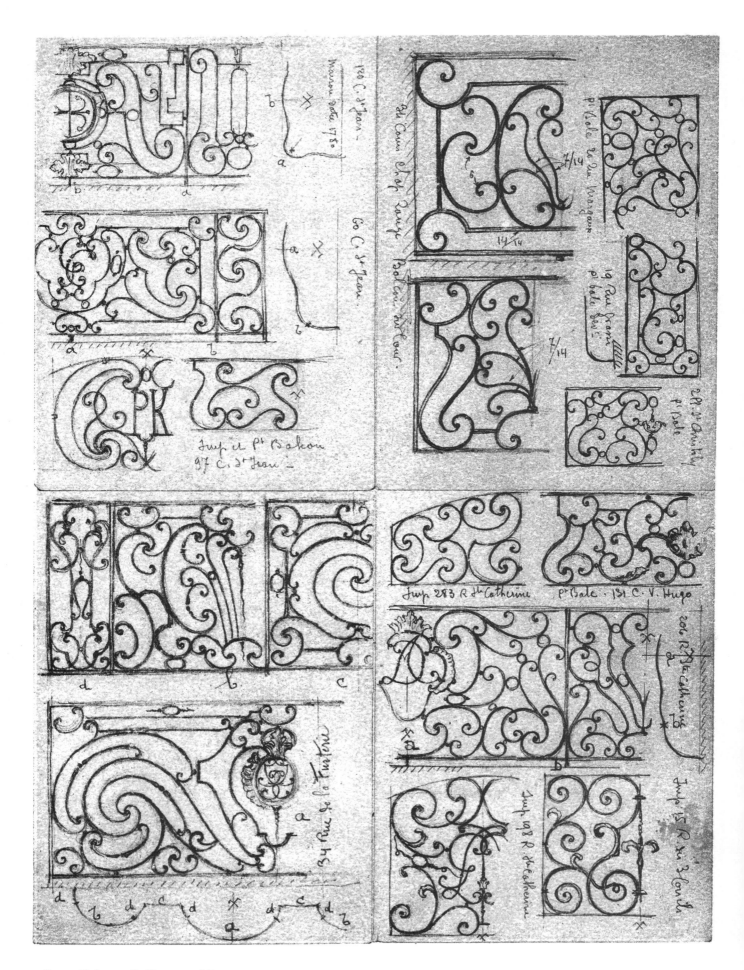

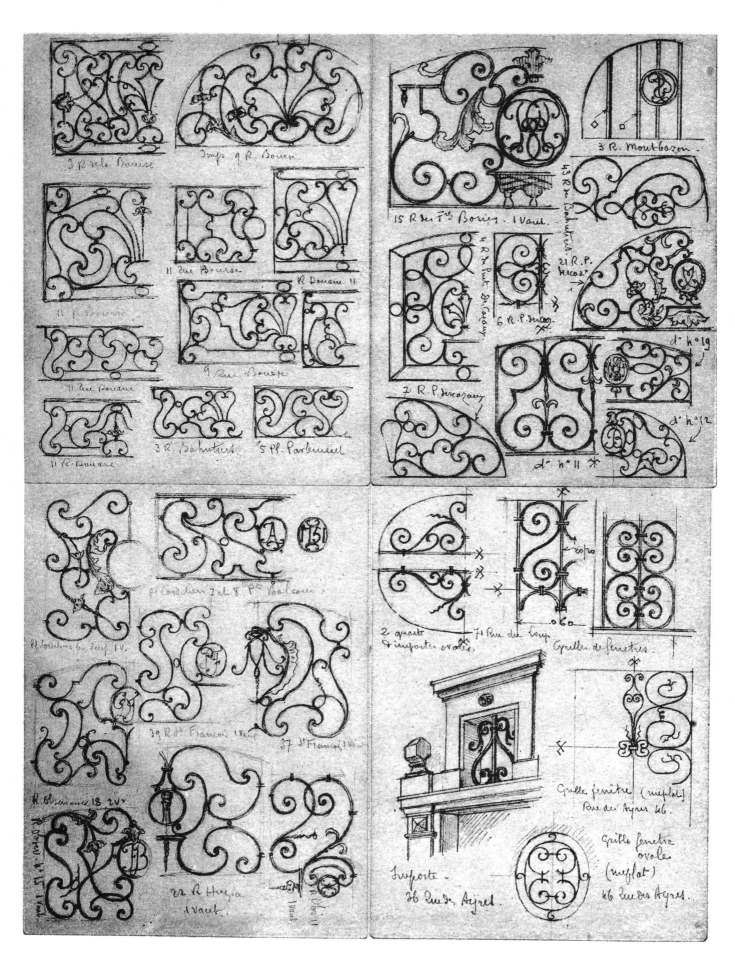

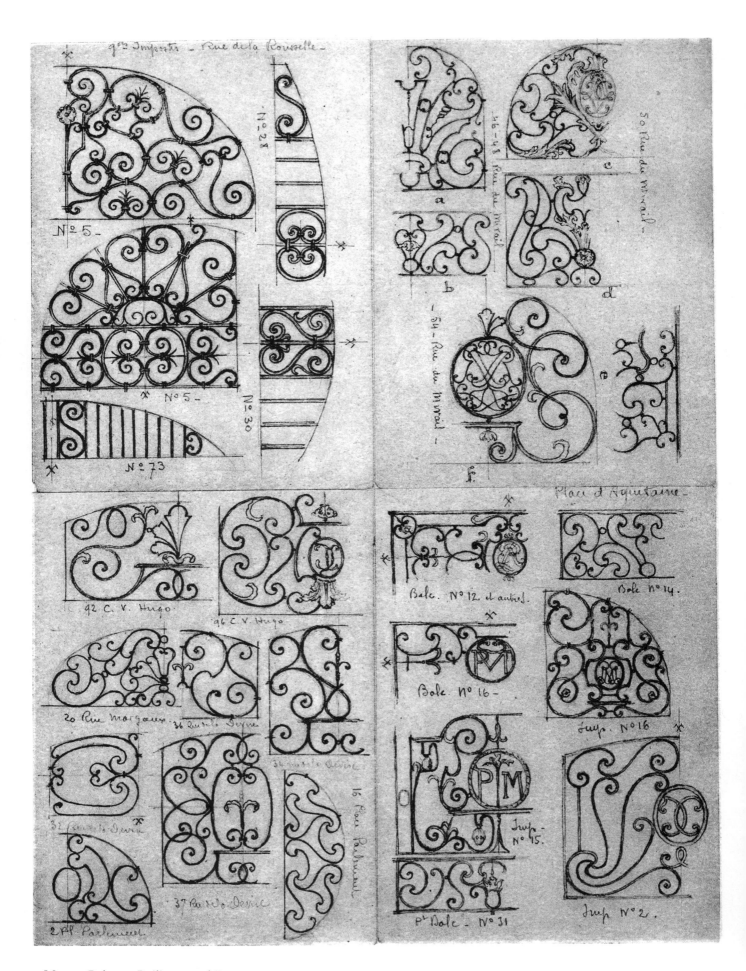

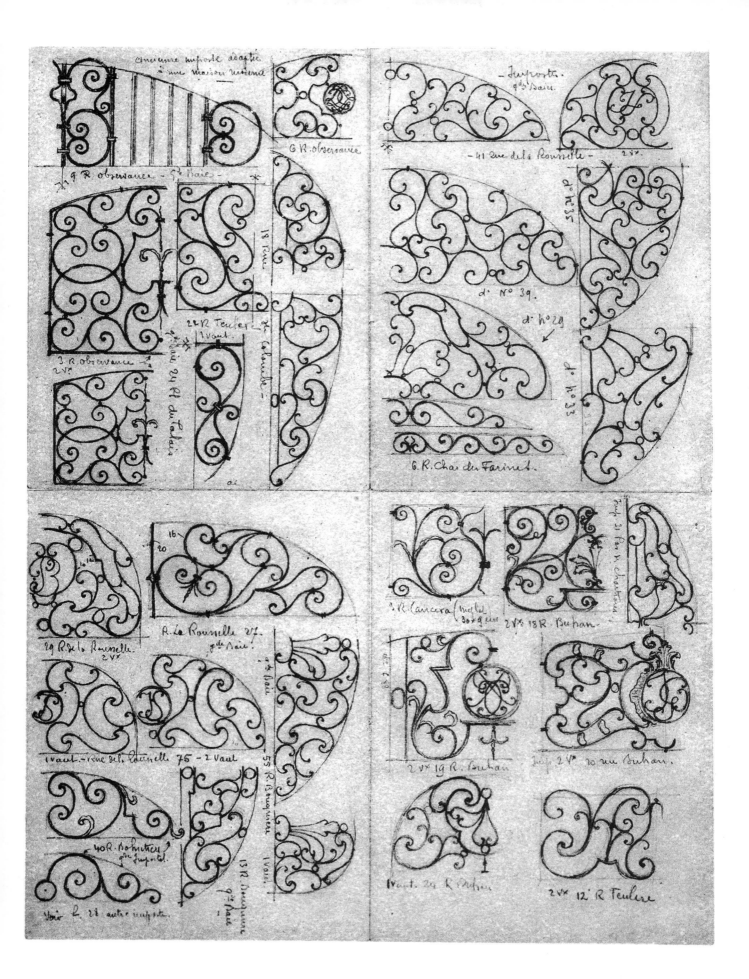

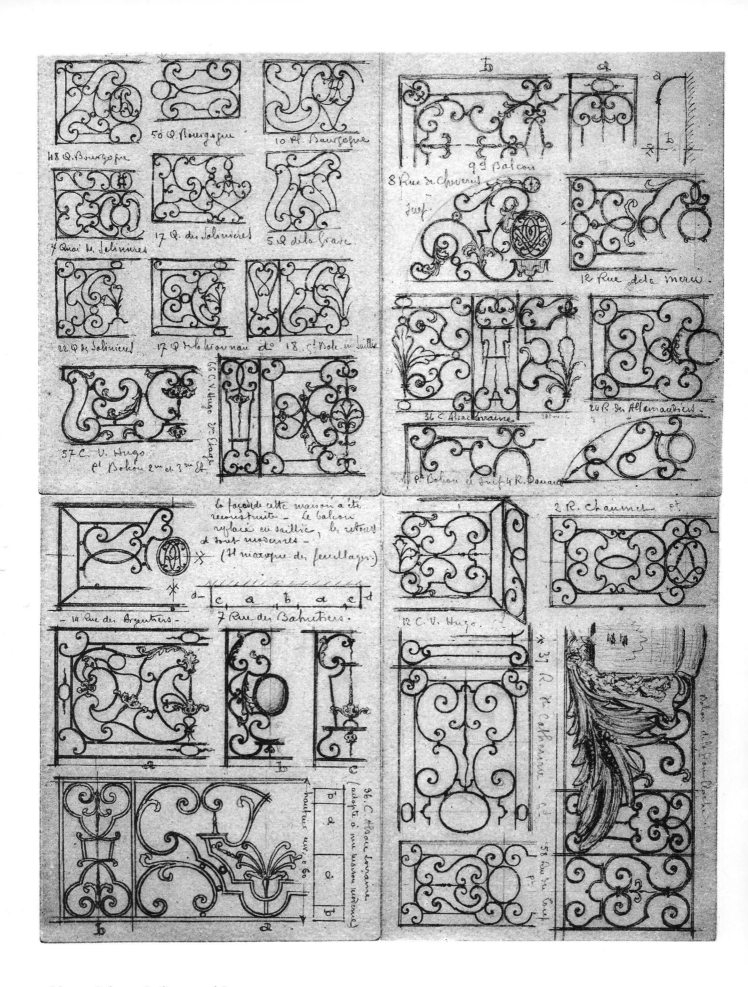

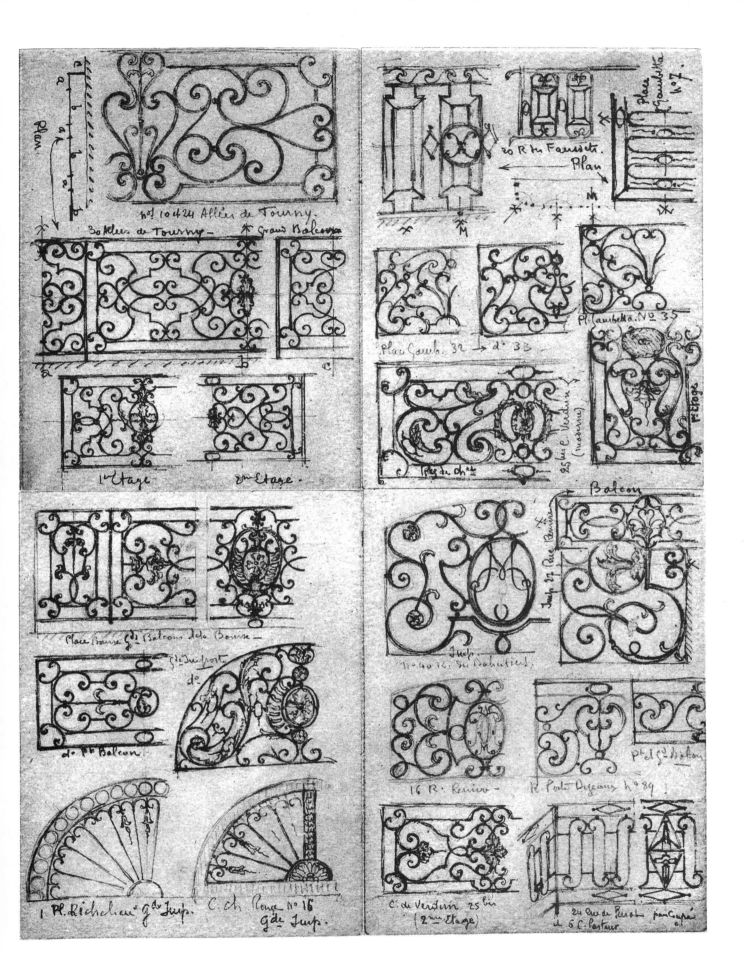

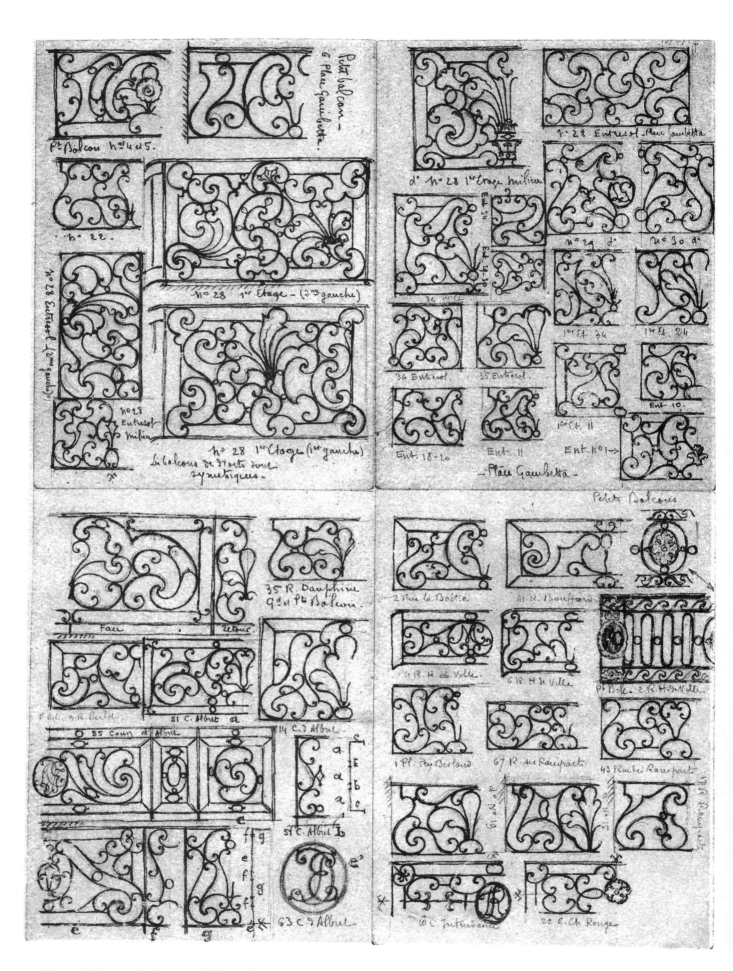

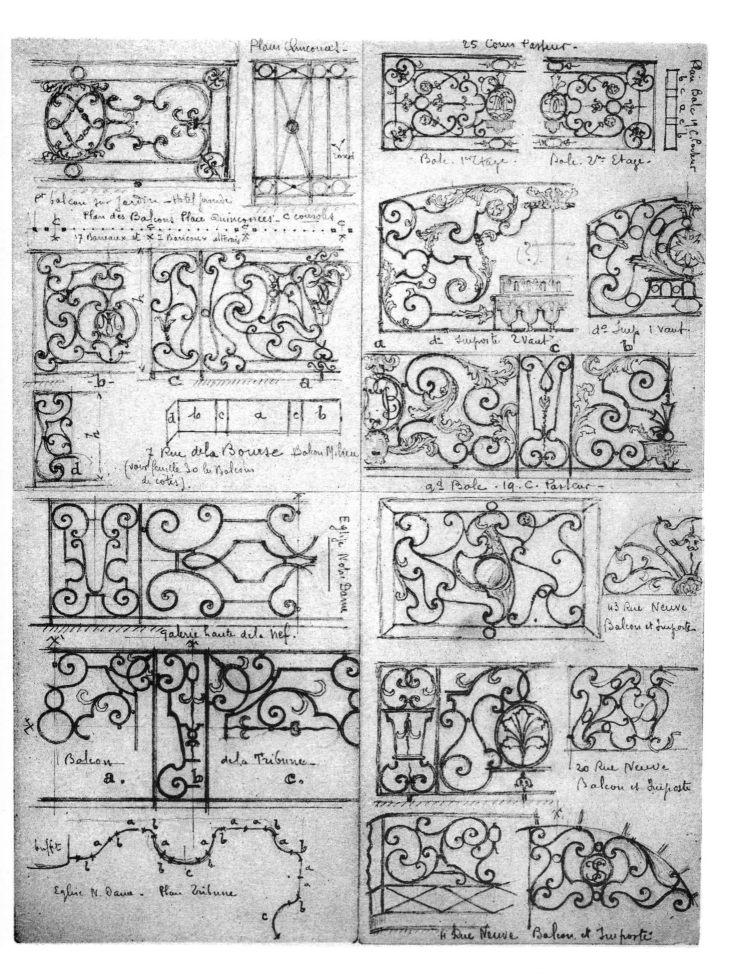

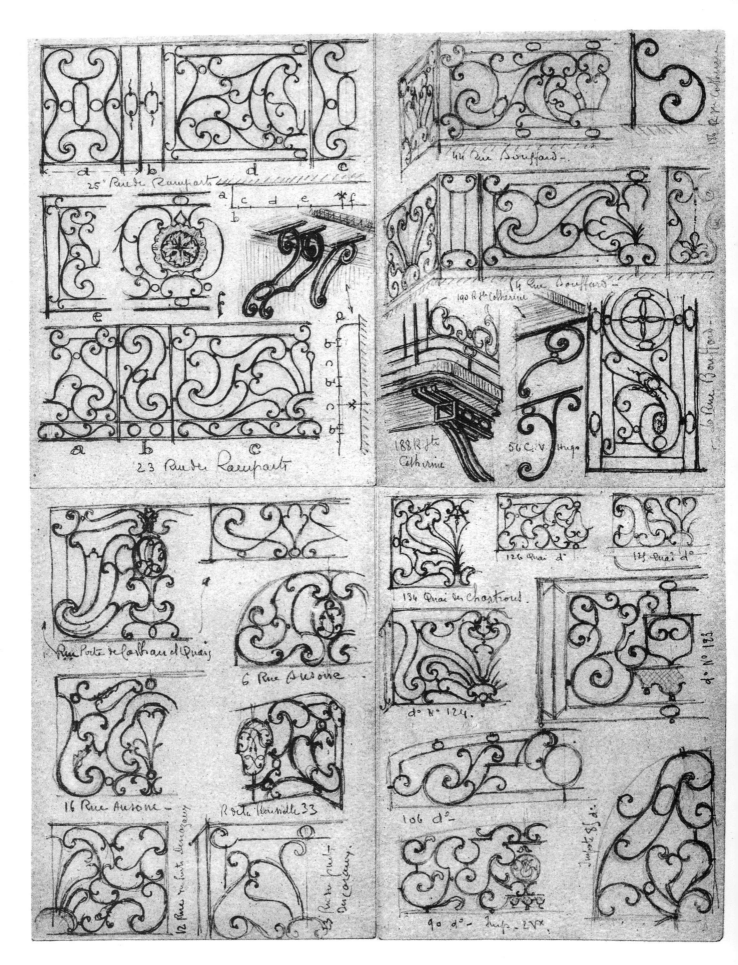

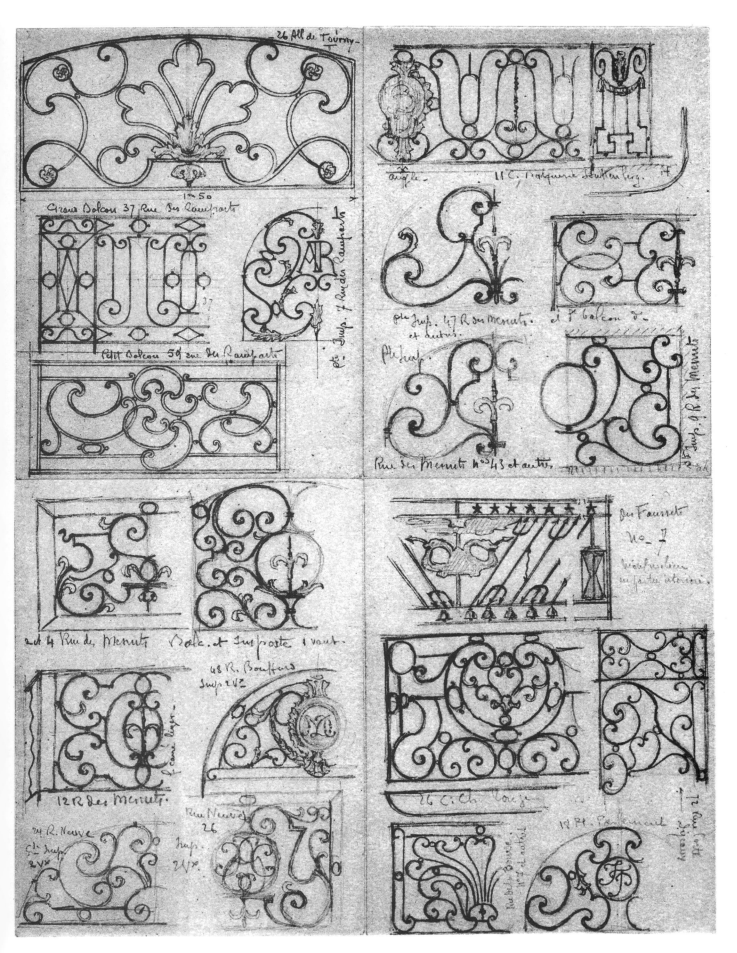

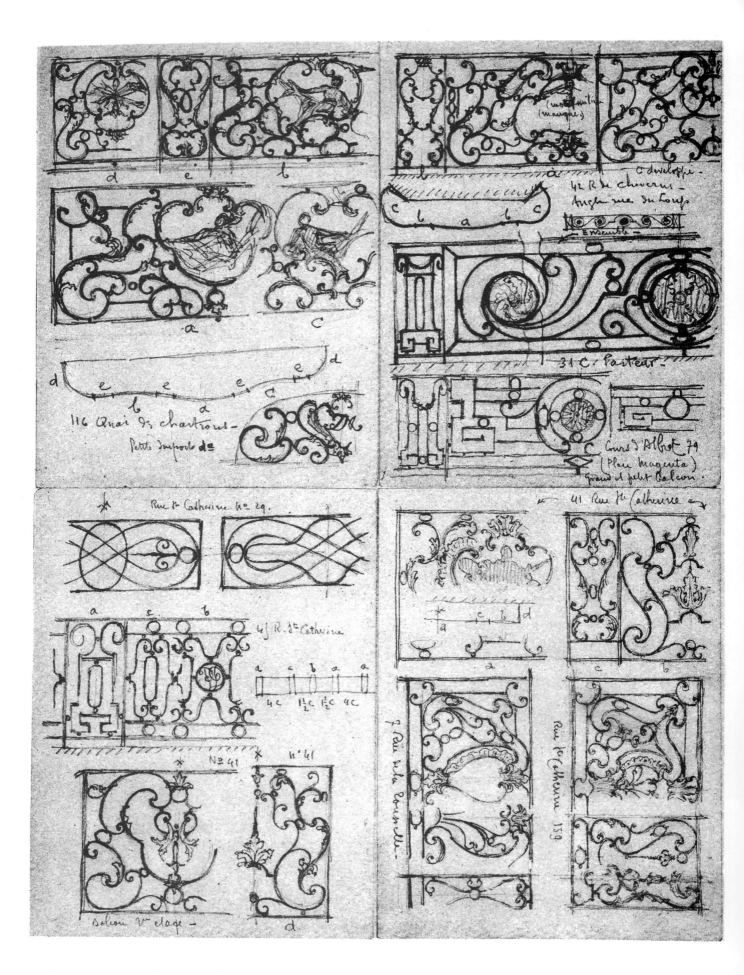

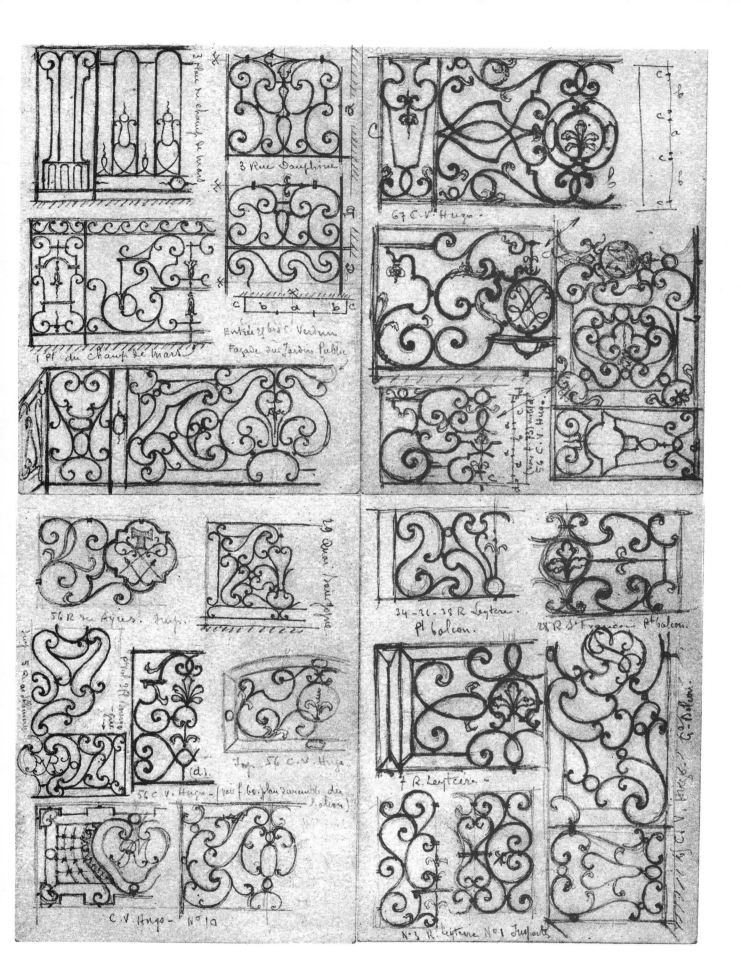

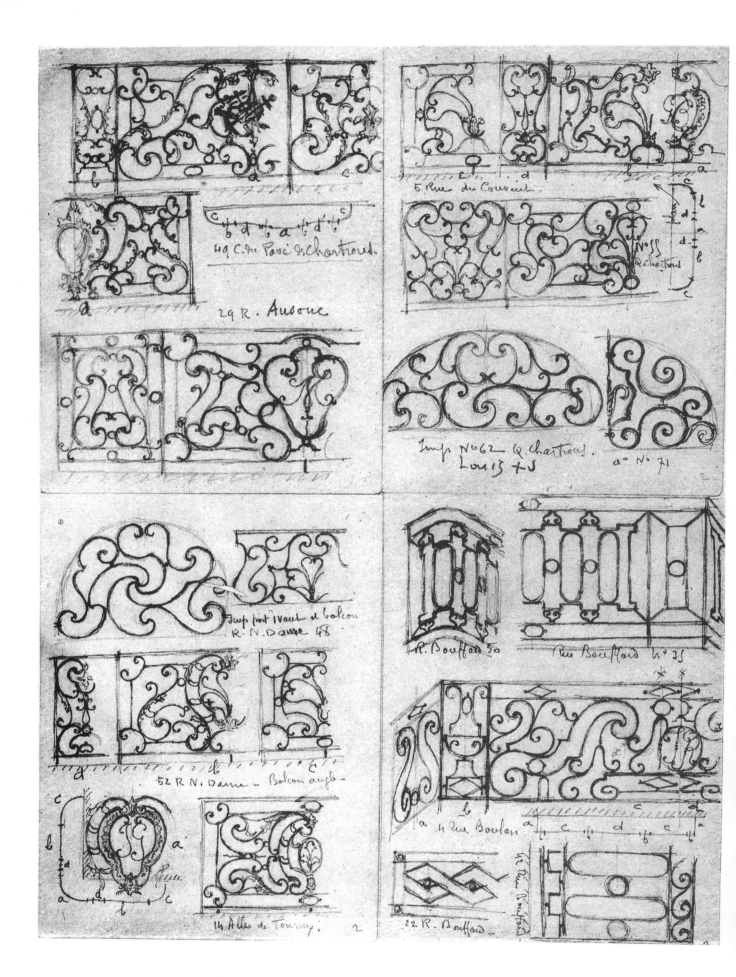

49 C. du Parc des Chartreux.

29 R. Ausone

5 Rue du Couvent.

N°55 Q. Chartreux

Imp N°62 Q. Chartreux.
Louis +J d° N° 71

Imp port Ivault et balcon
R. N. Dame 48

R. Bouffard 50 Rue Bouffard N° 35

52 R. N. Dame — Balcon anglé

14 Rue Boulan

14 Allée de Tourny 22 R. Bouffard

20 Balcony Railings, and Imposts

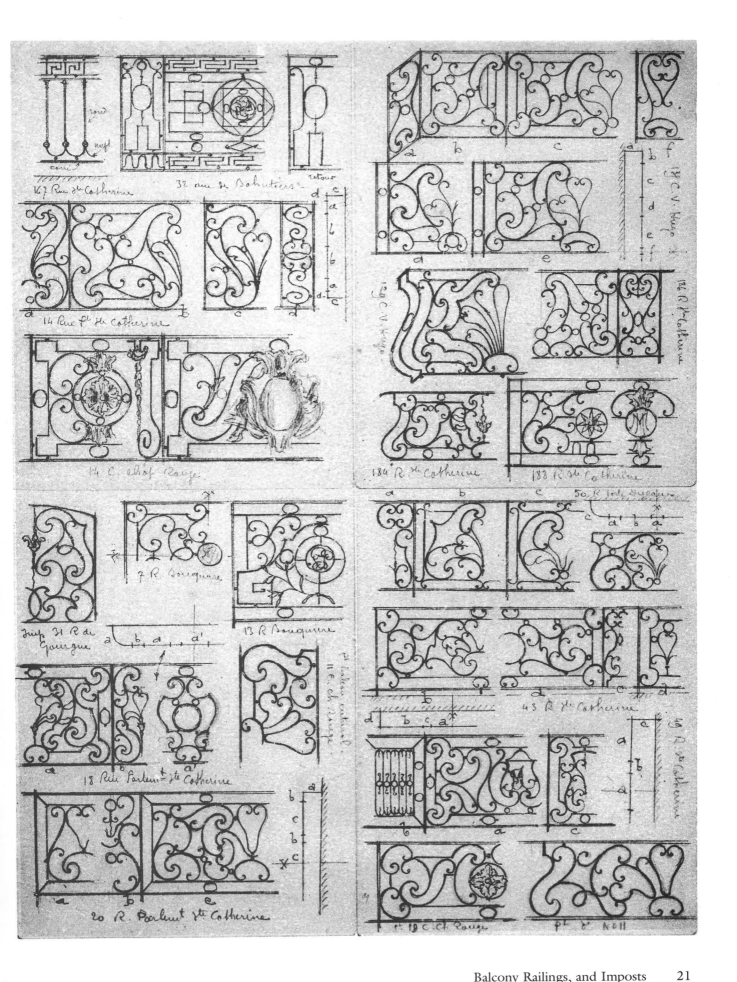

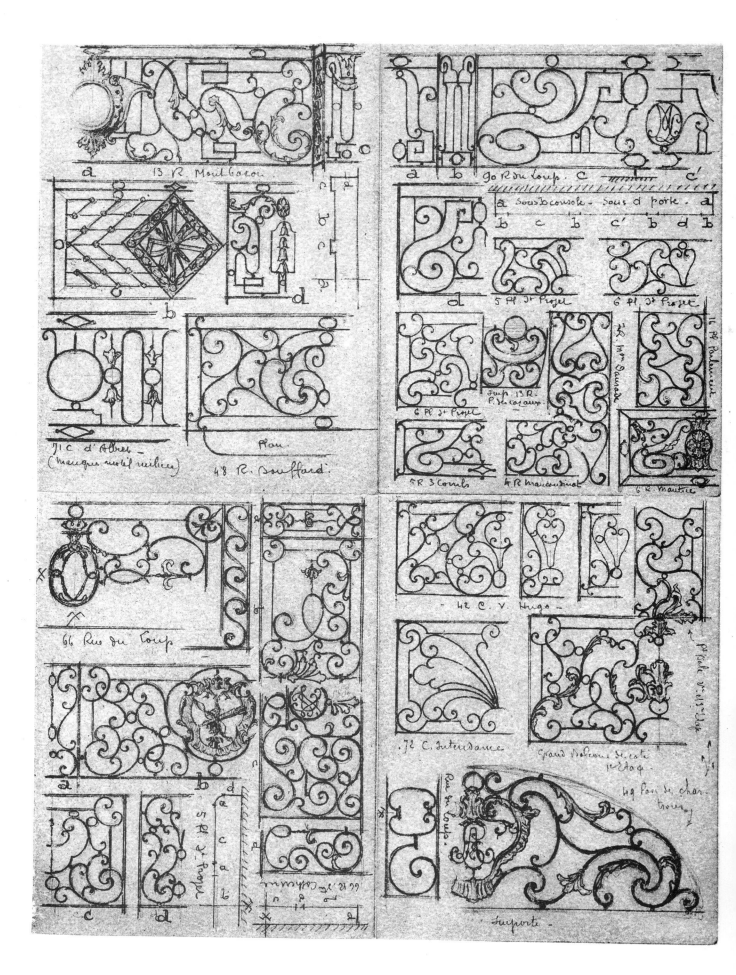

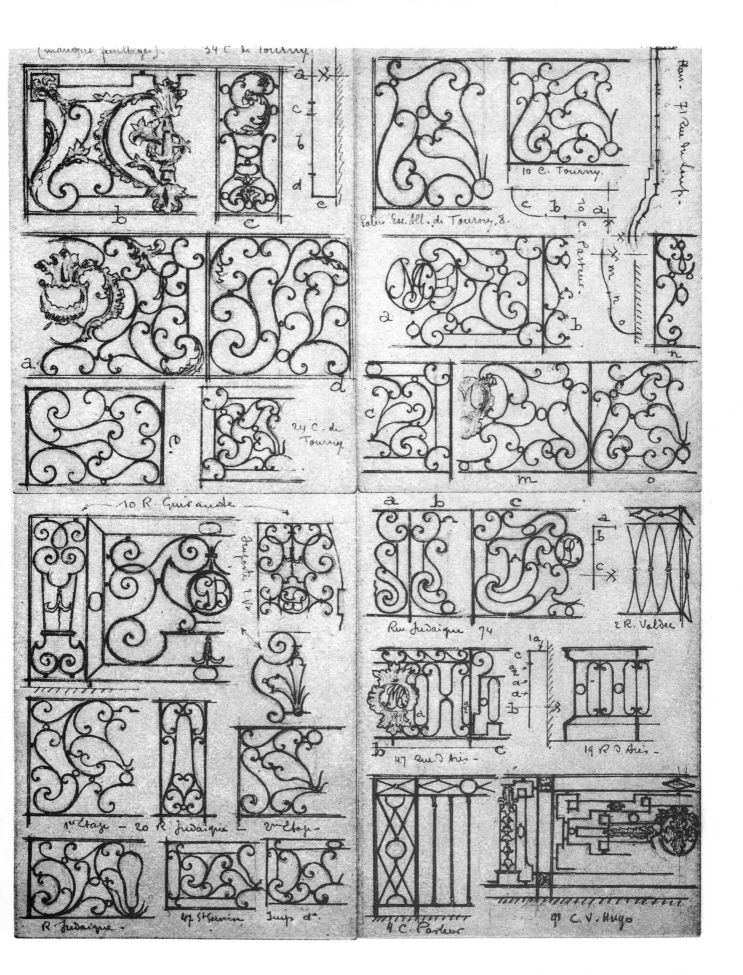

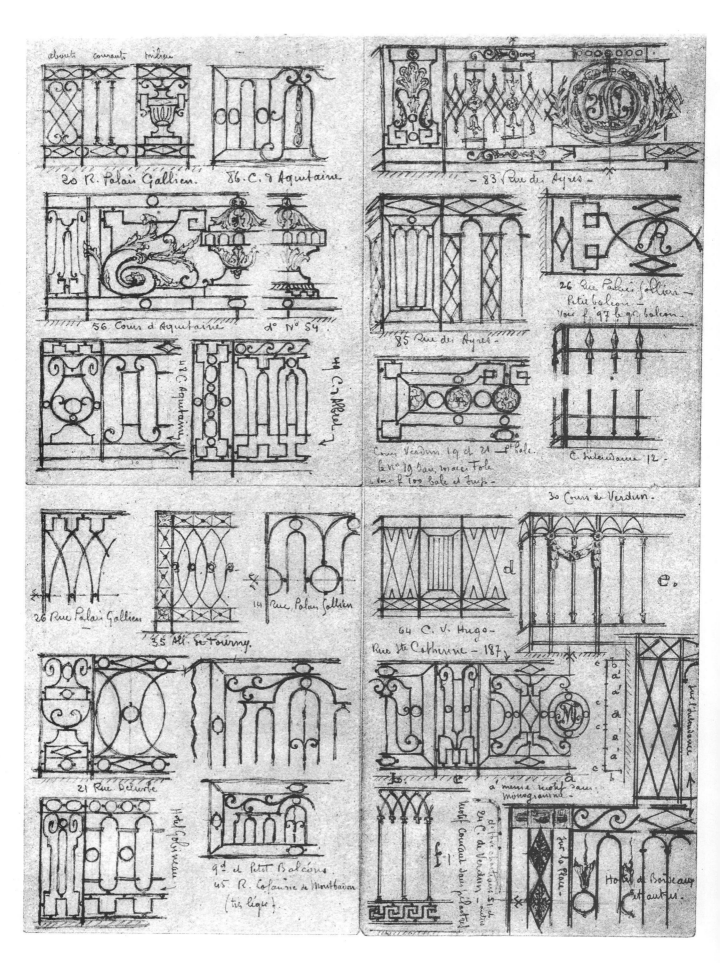

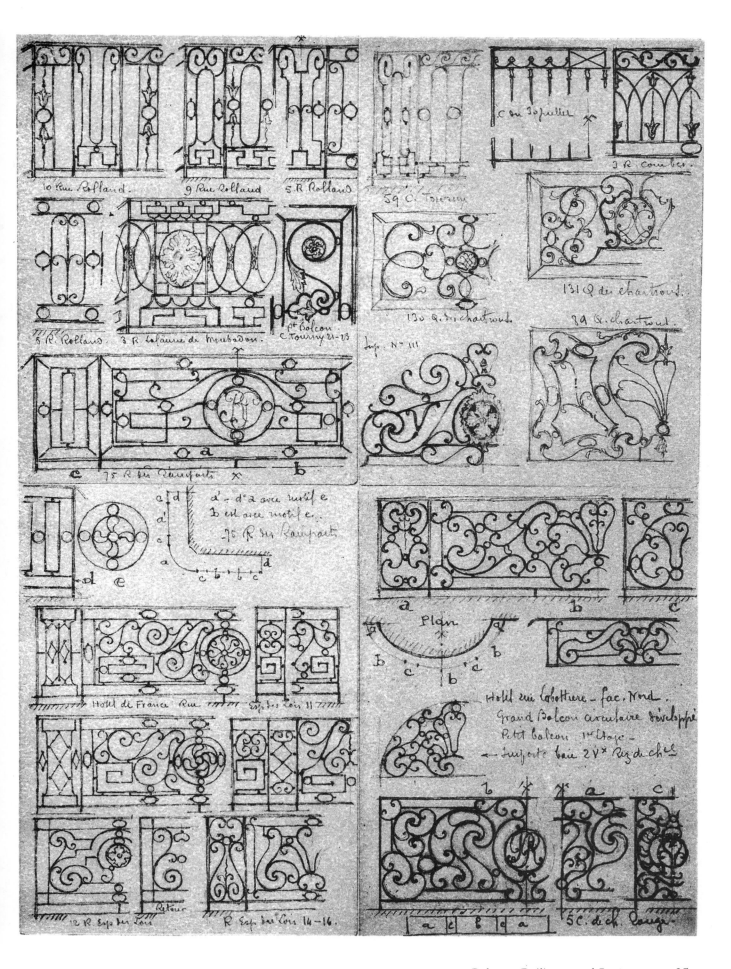

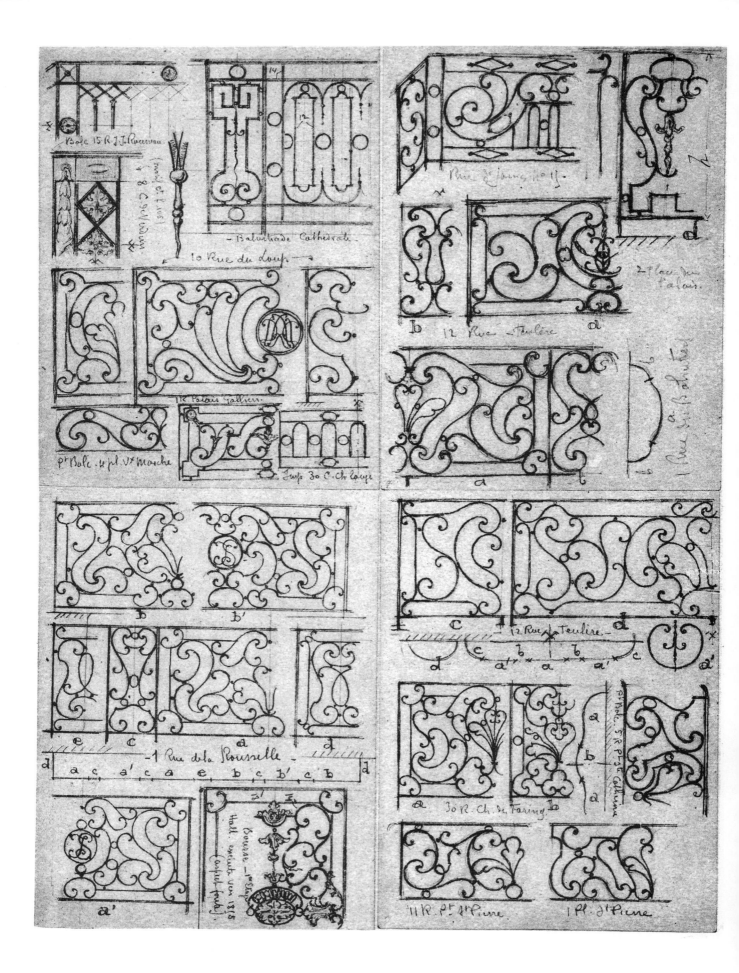

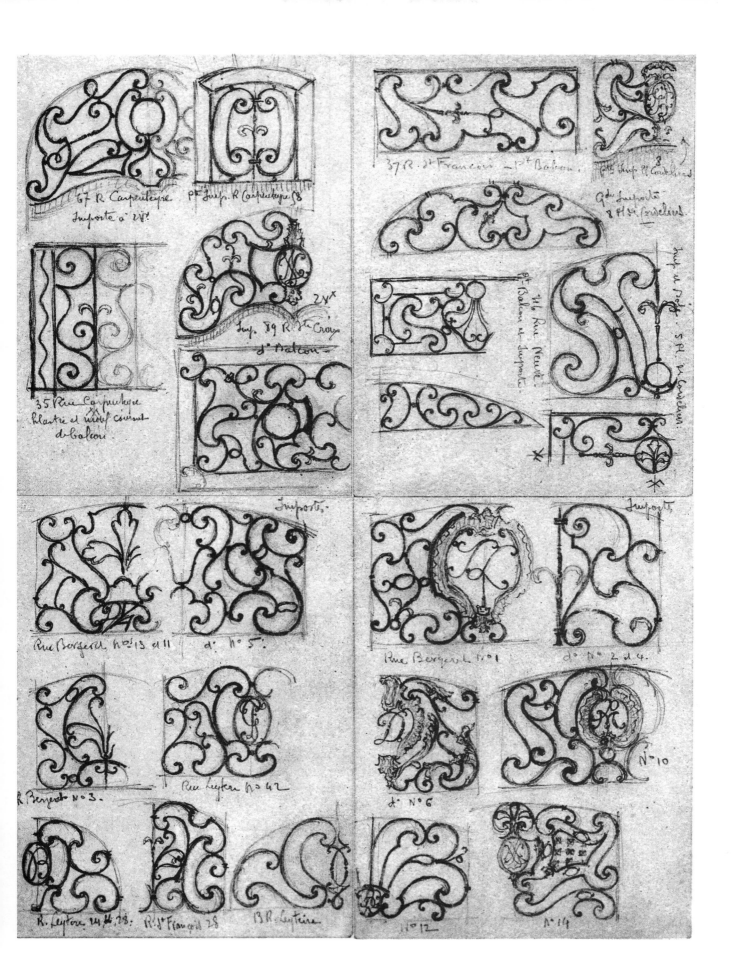

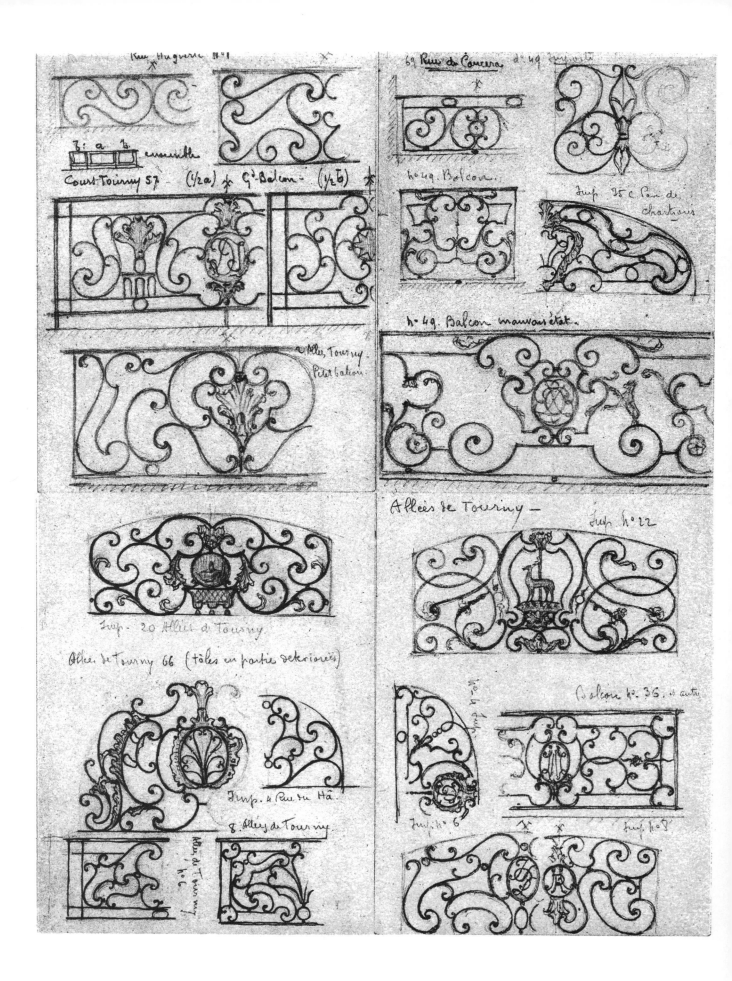

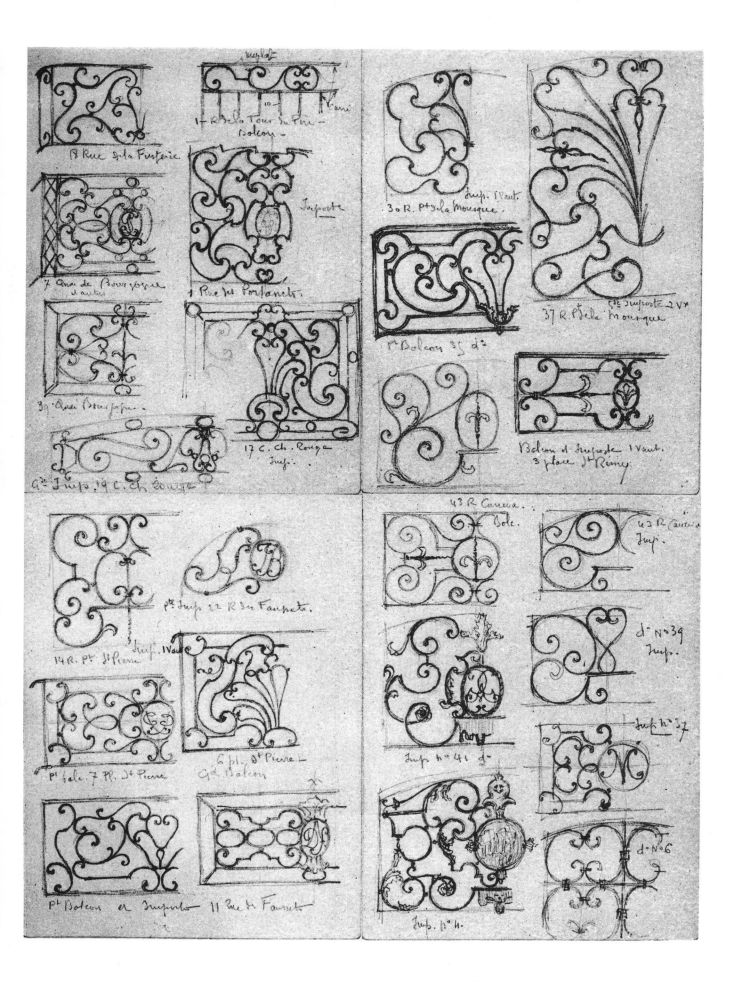

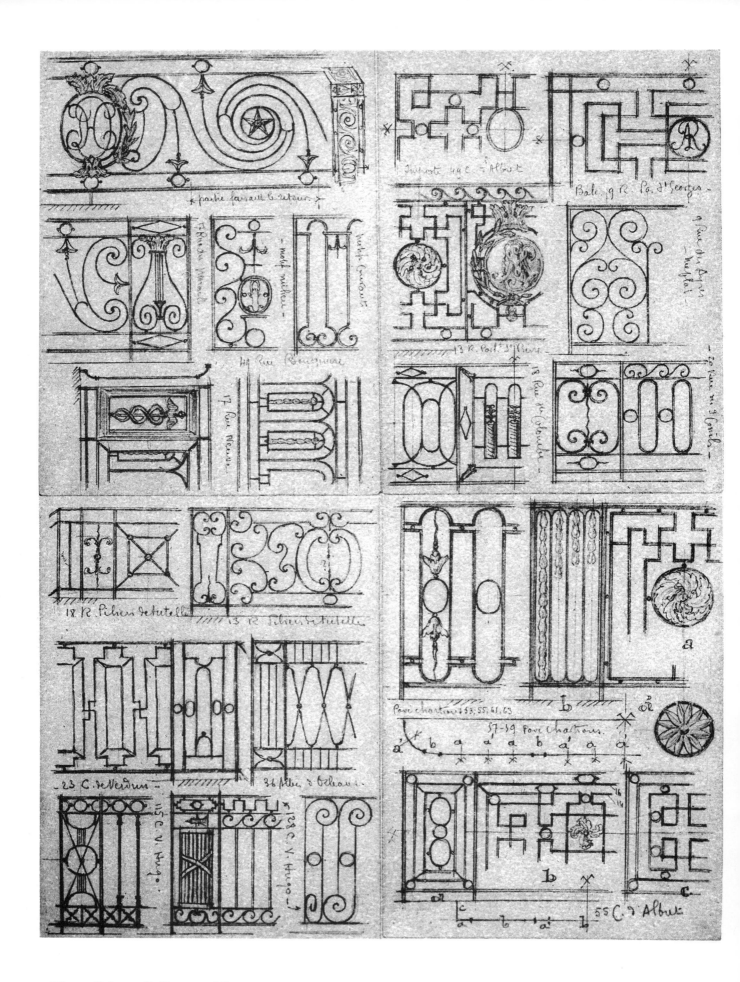

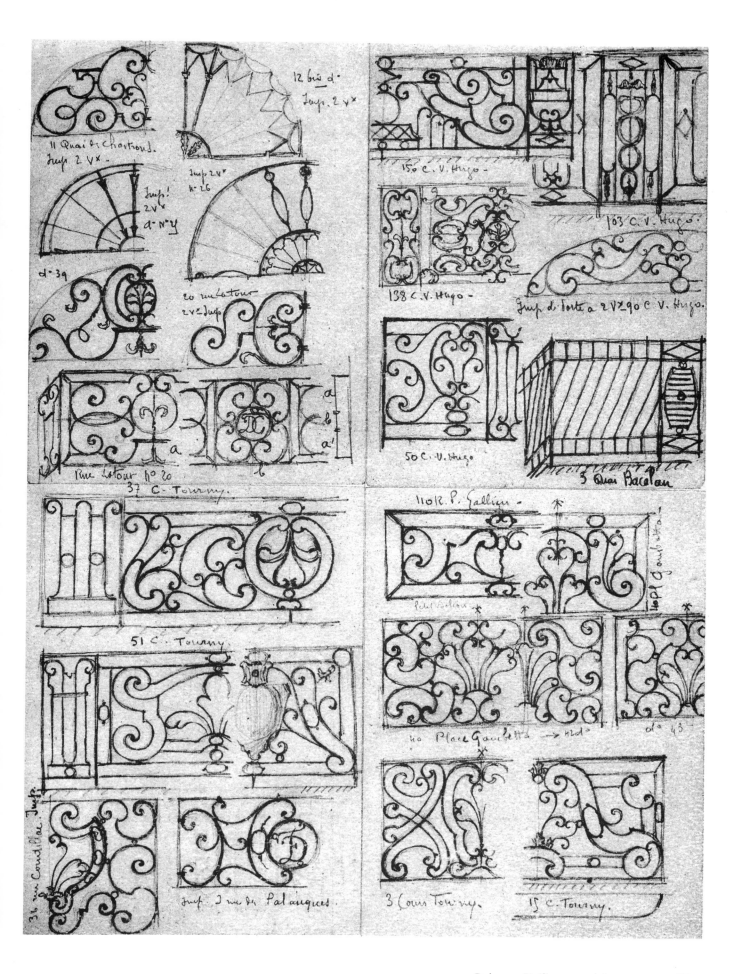

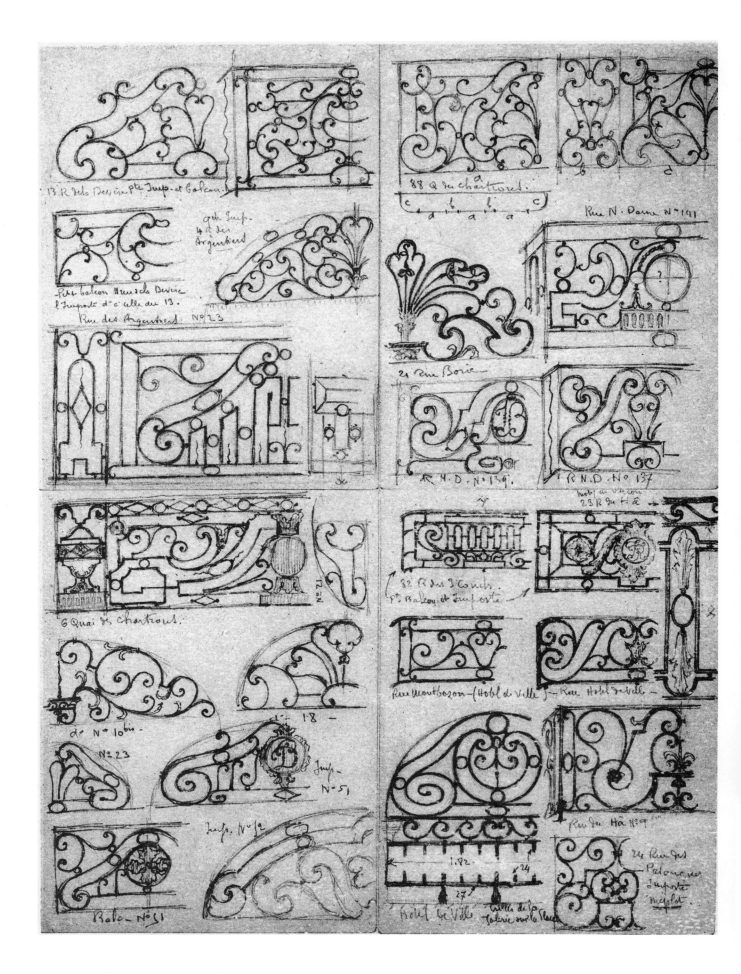

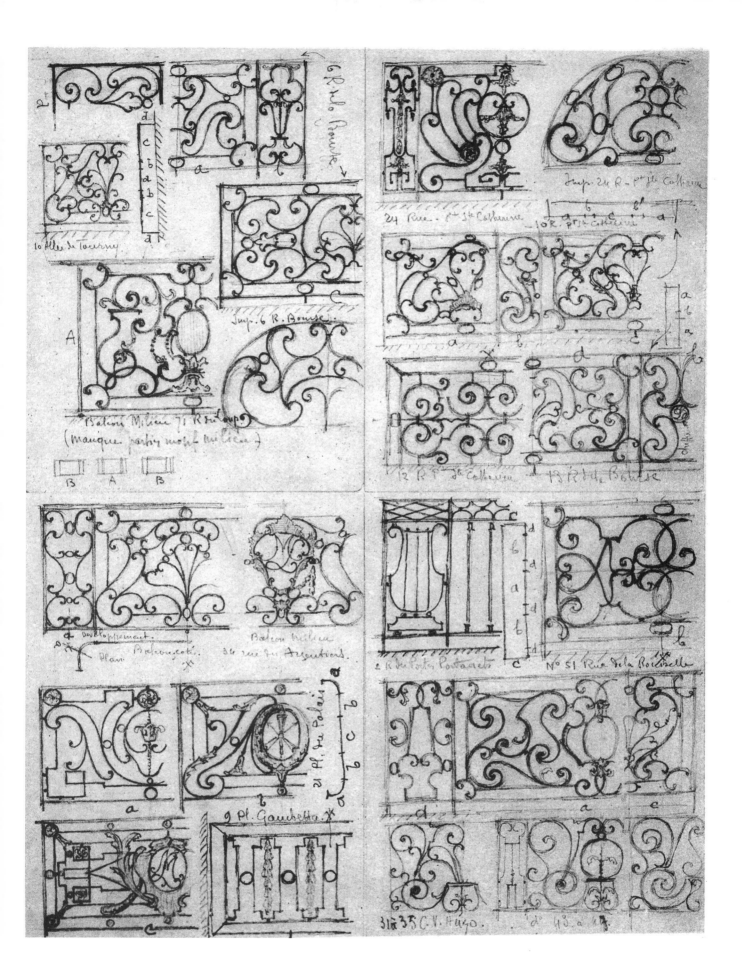

Balcony Railings, and Imposts 33

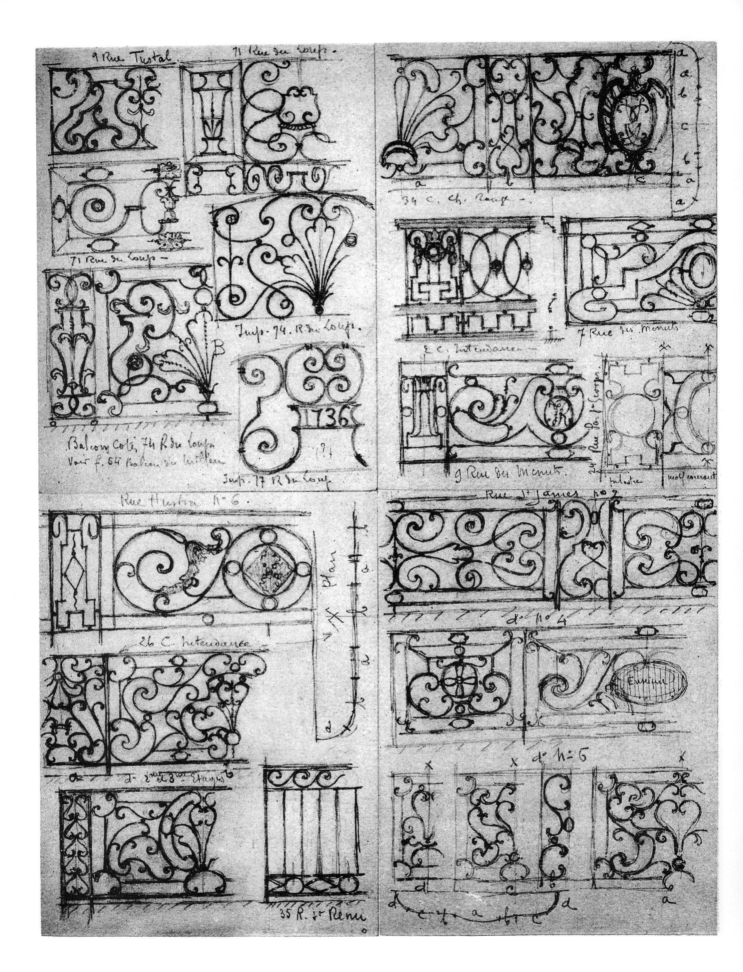

34 Balcony Railings, and Imposts

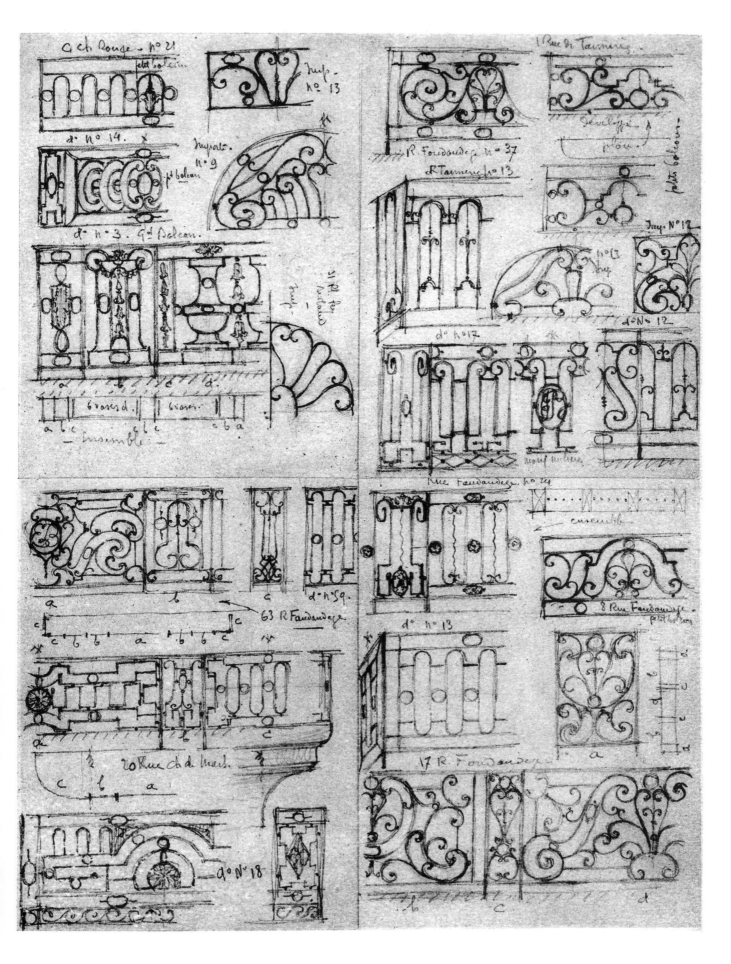

Balcony Railings, and Imposts 35

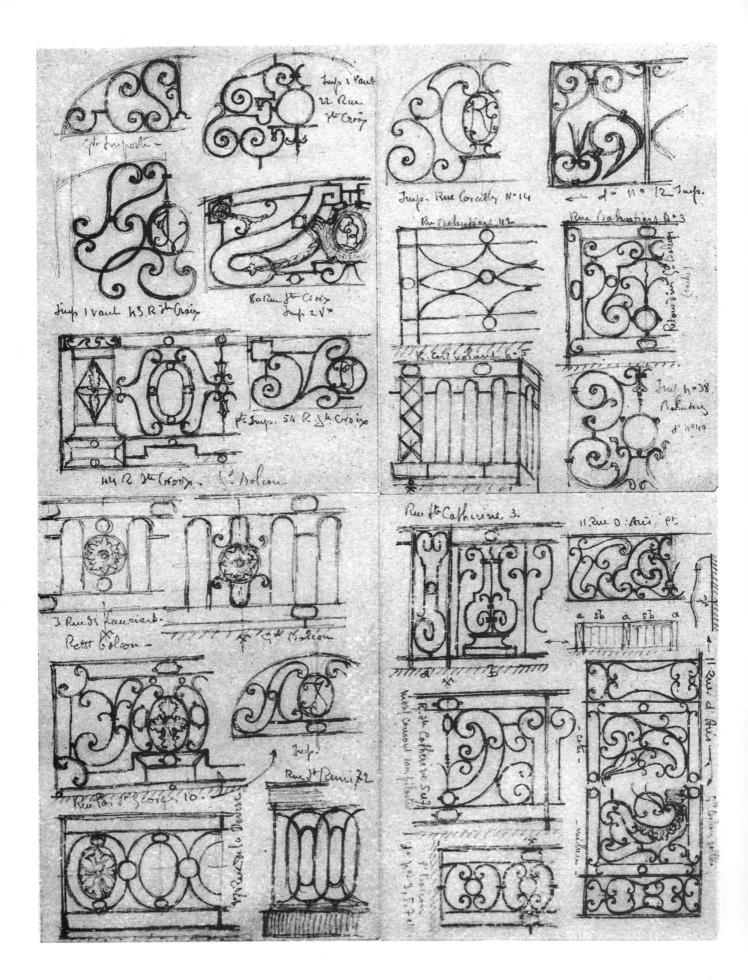

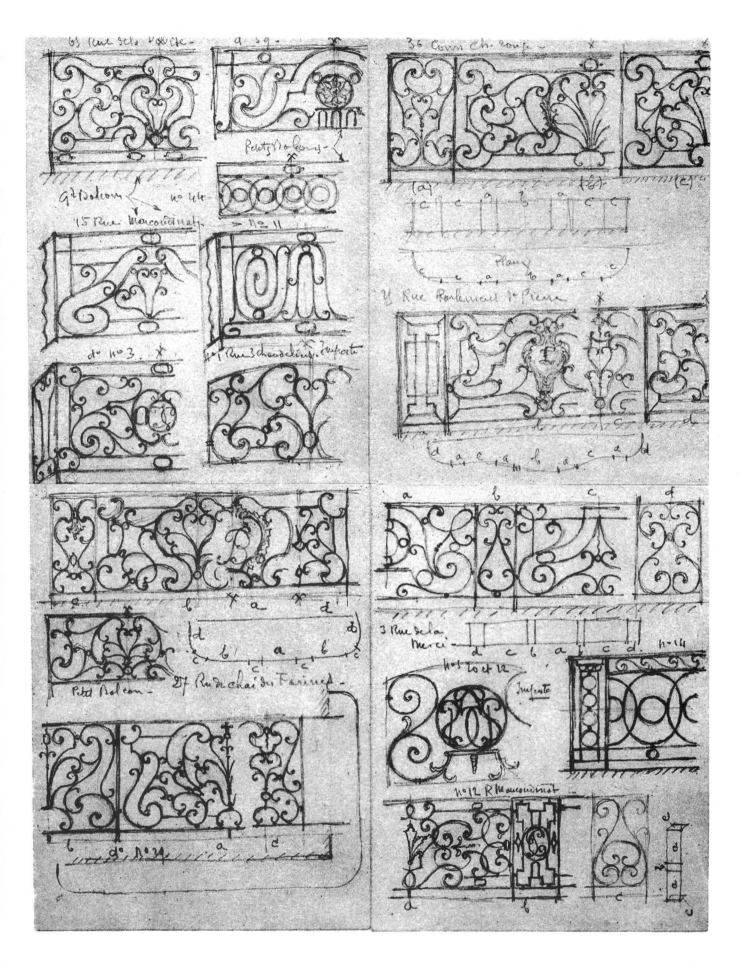

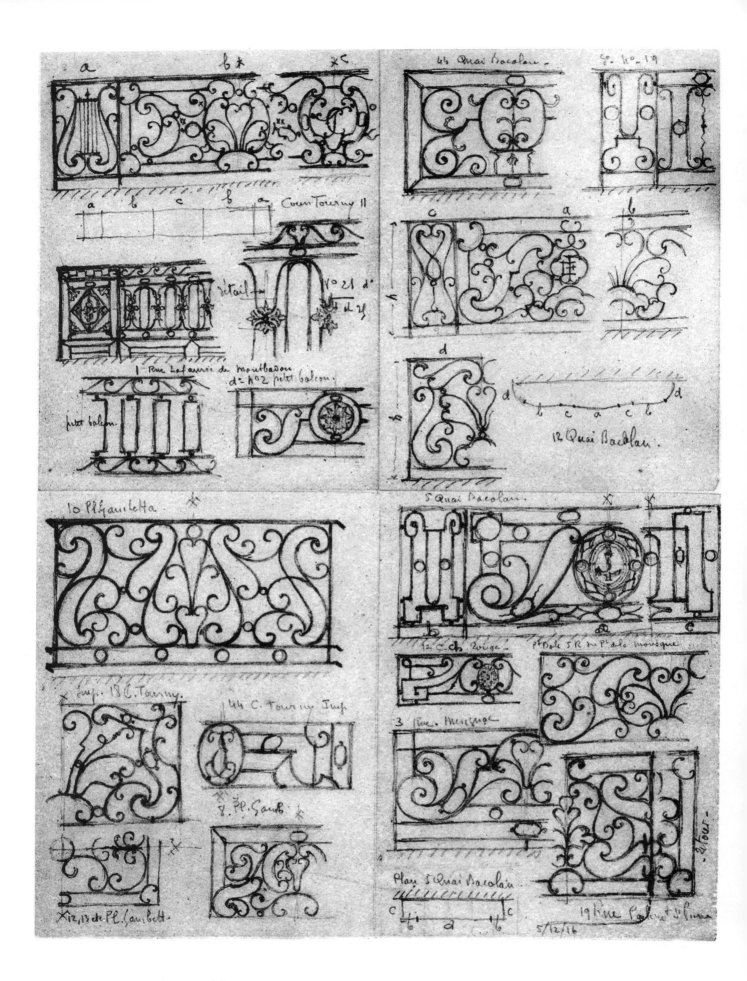

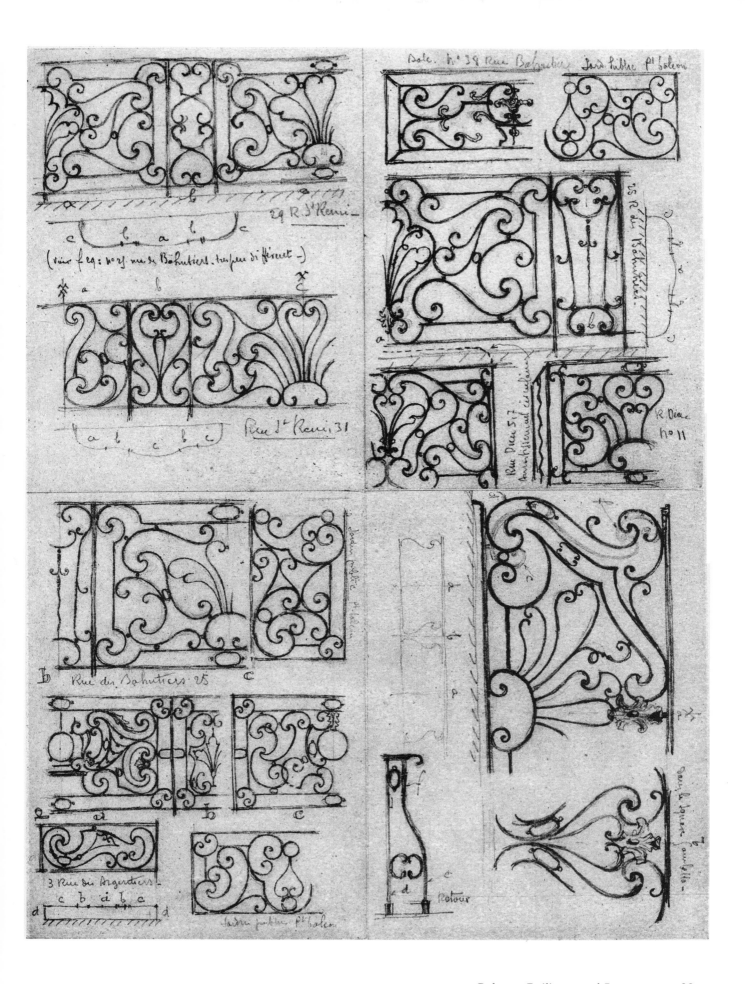

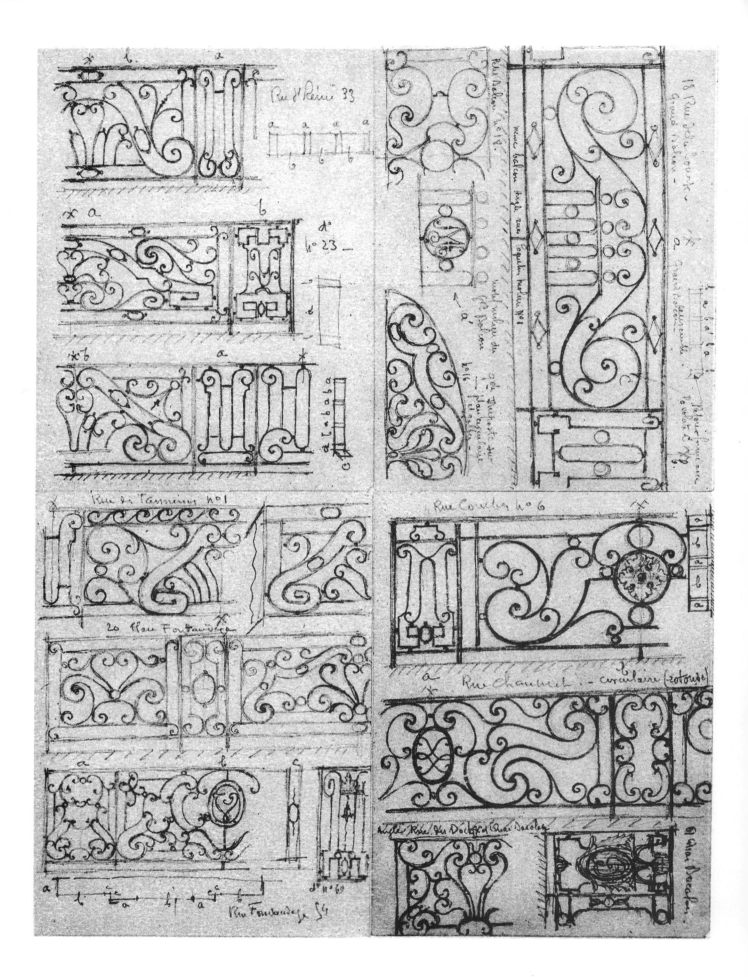

40 Balcony Railings, and Imposts

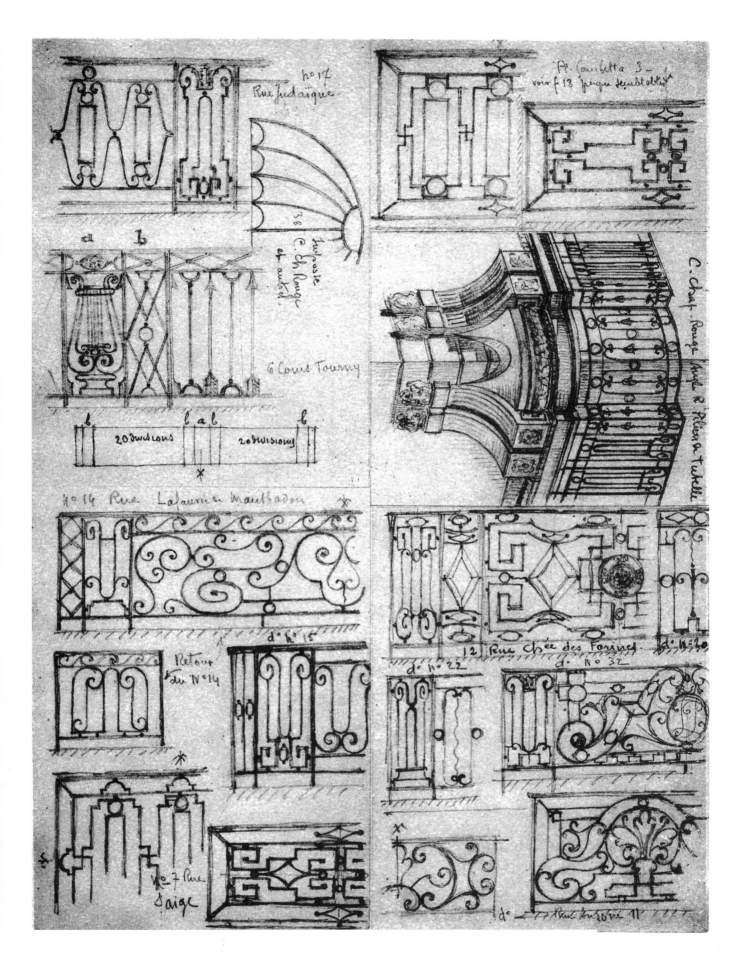

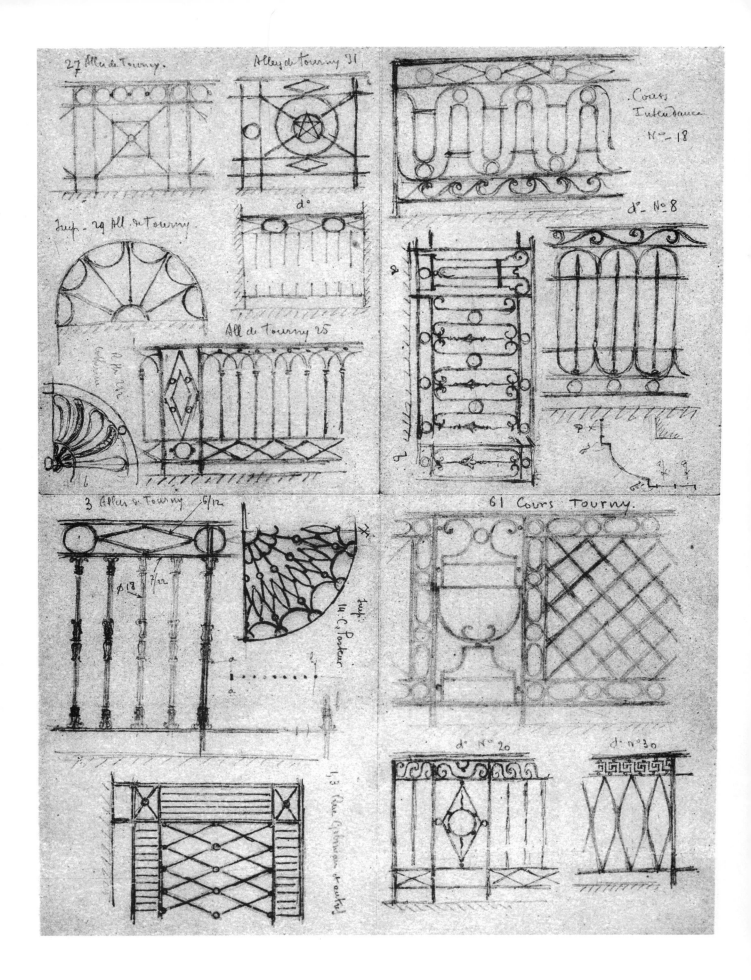

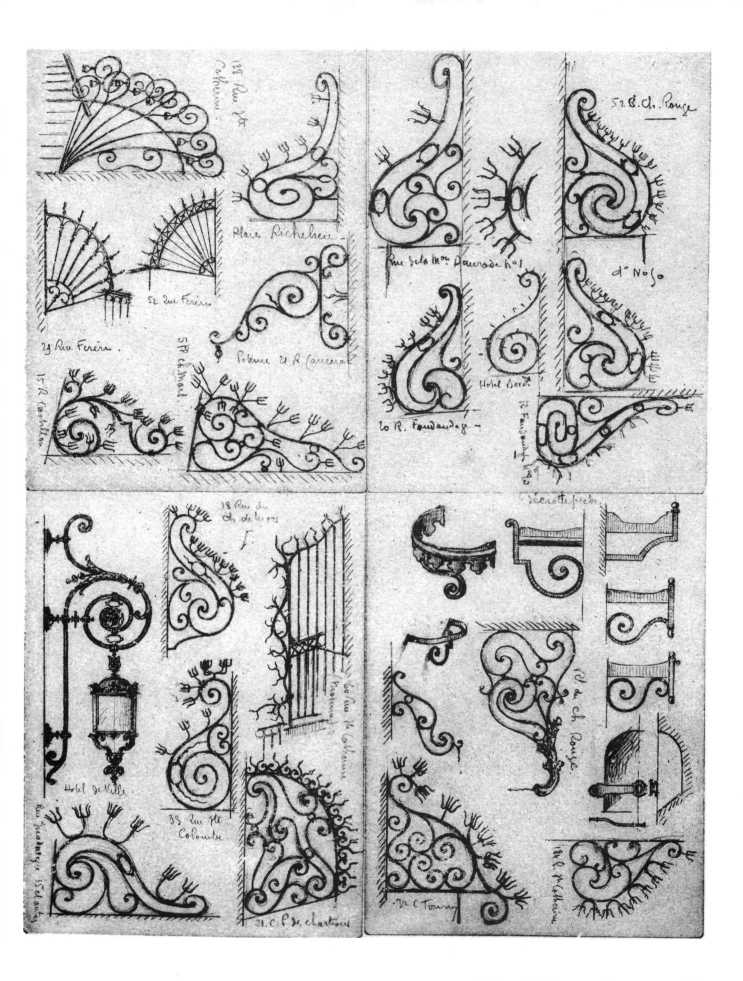

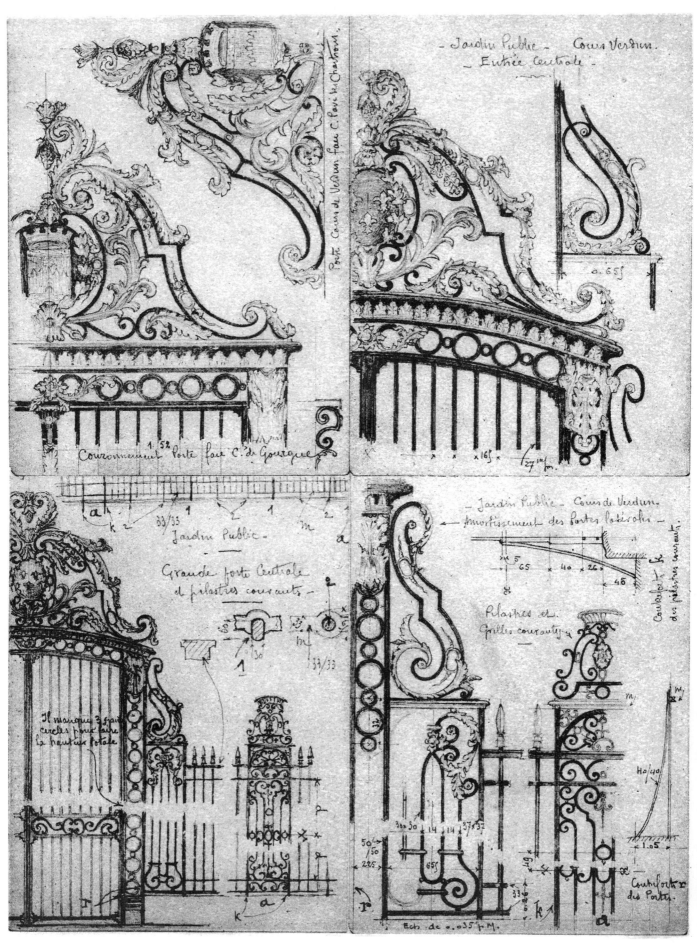

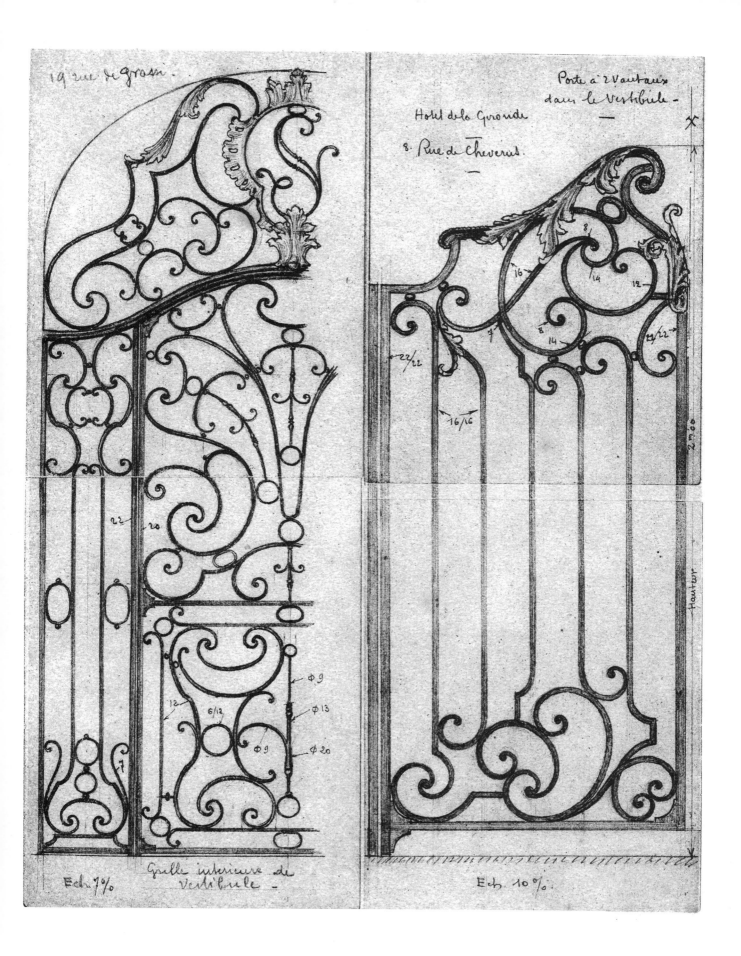

19 rue de Grassi -

Hôtel de la Gironde

8. Rue de Cheverus -

Porte à 2 vantaux
dans le Vestibule -

Grille intérieure de
Vestibule -

Ech. 7%

Ech. 10%

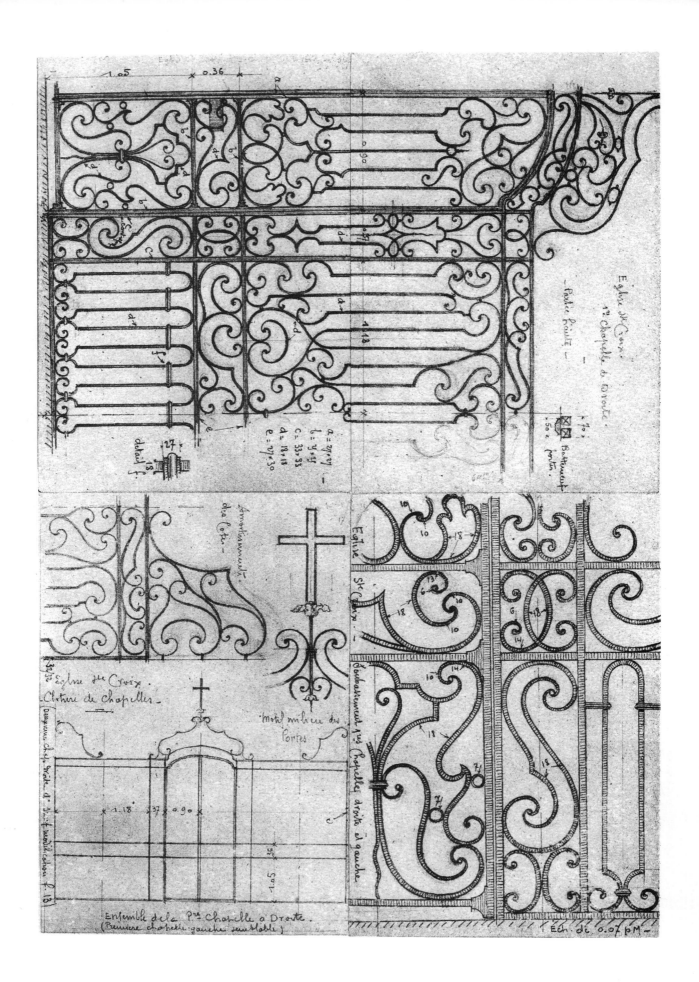

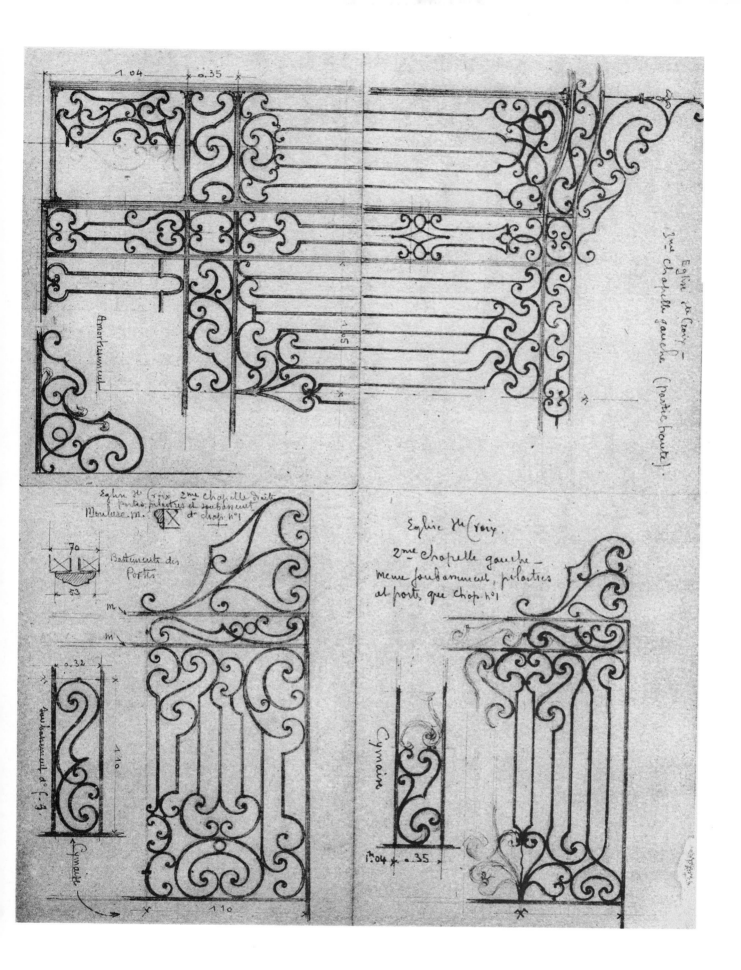

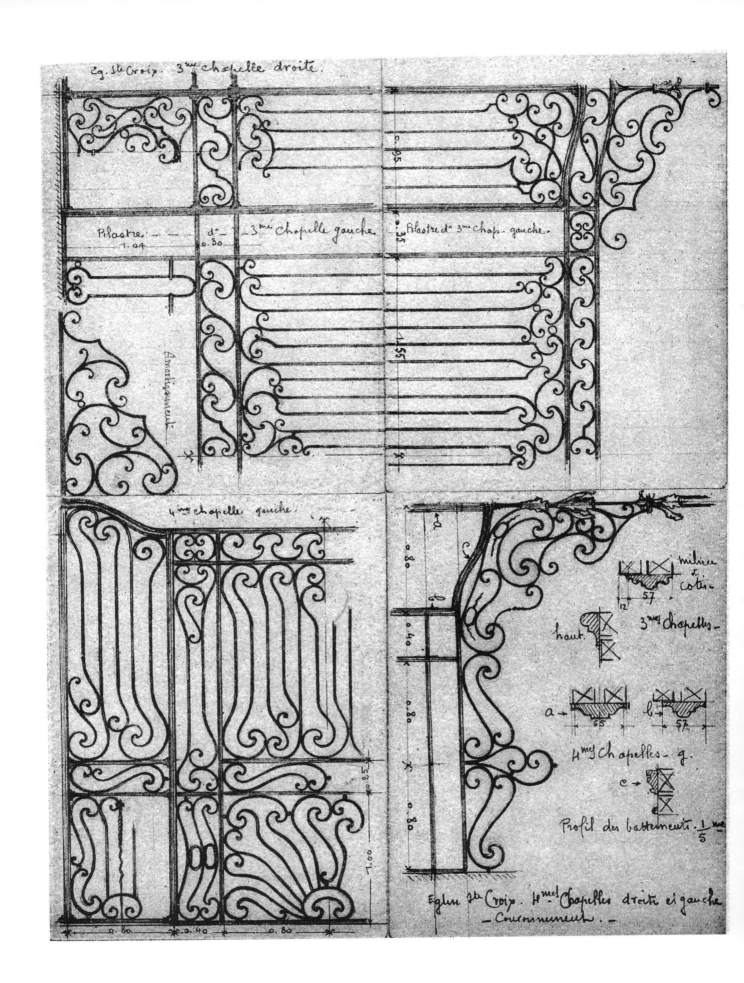

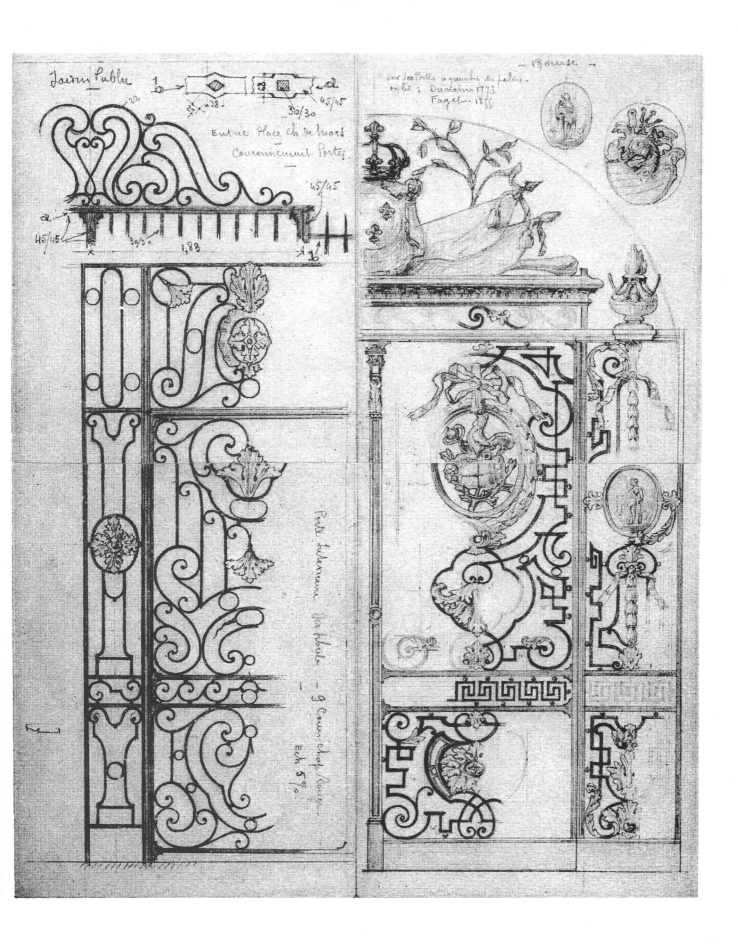

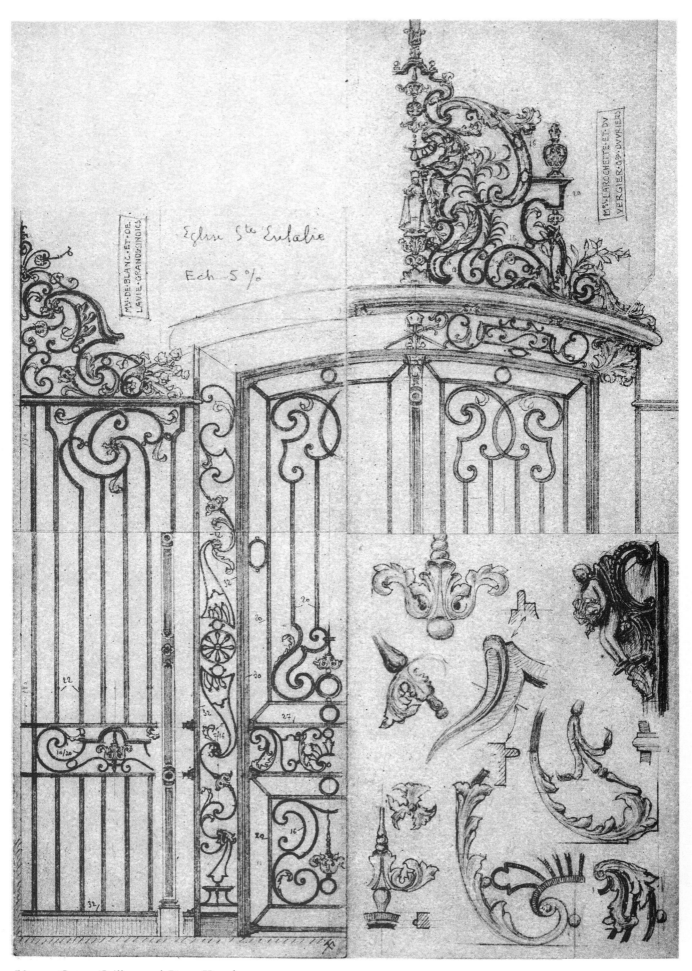

Eglise Ste Eulalie

Ech 5 %

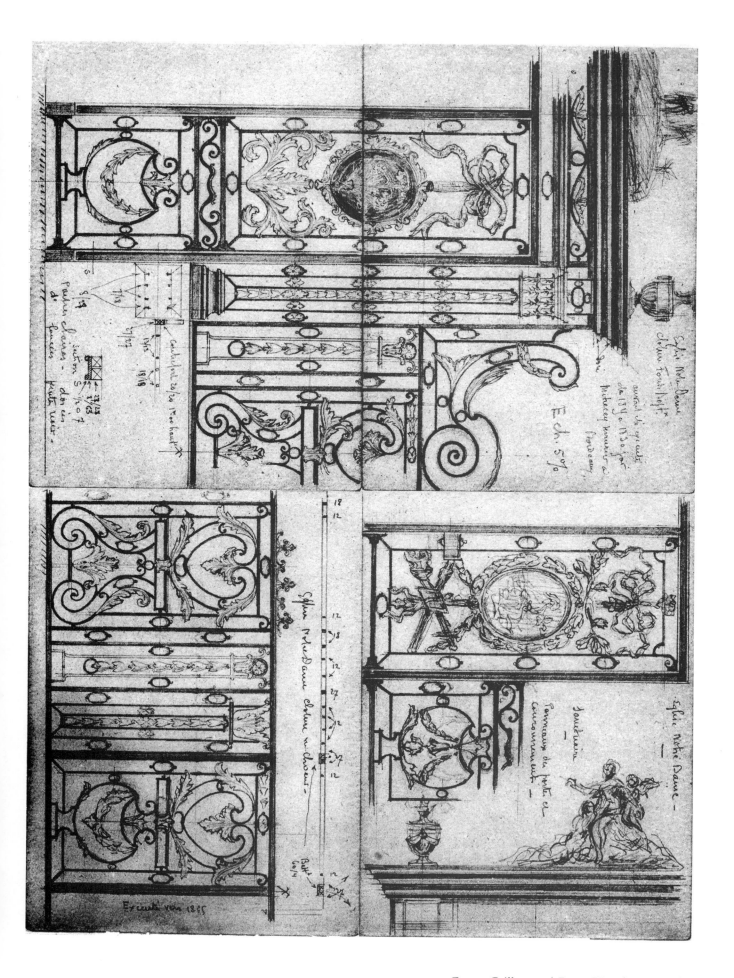

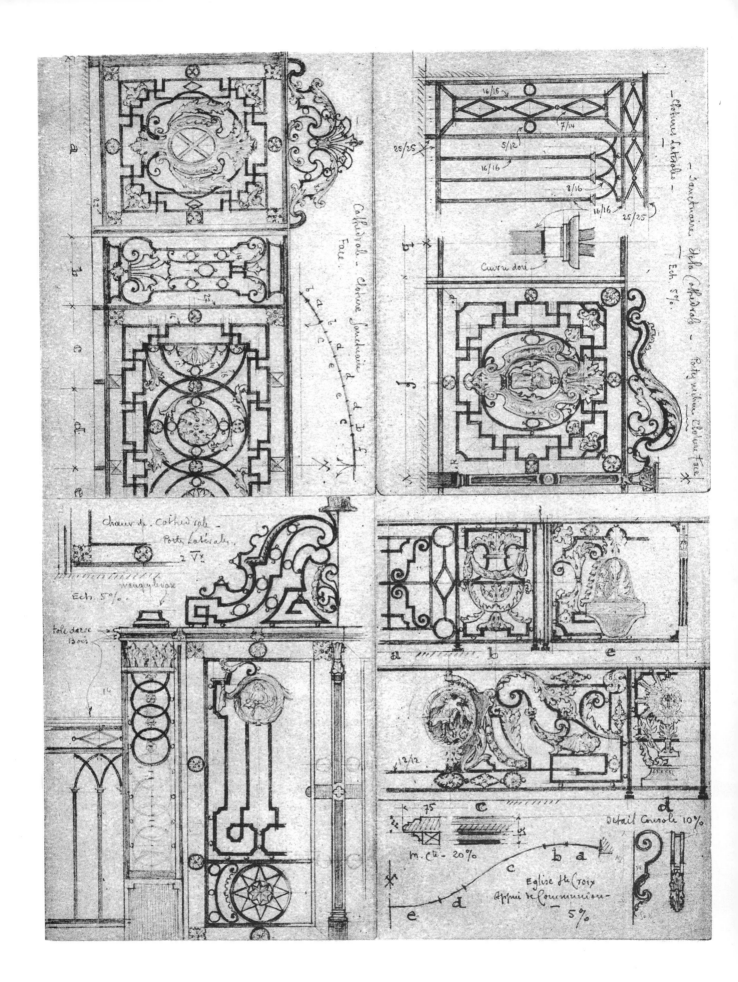

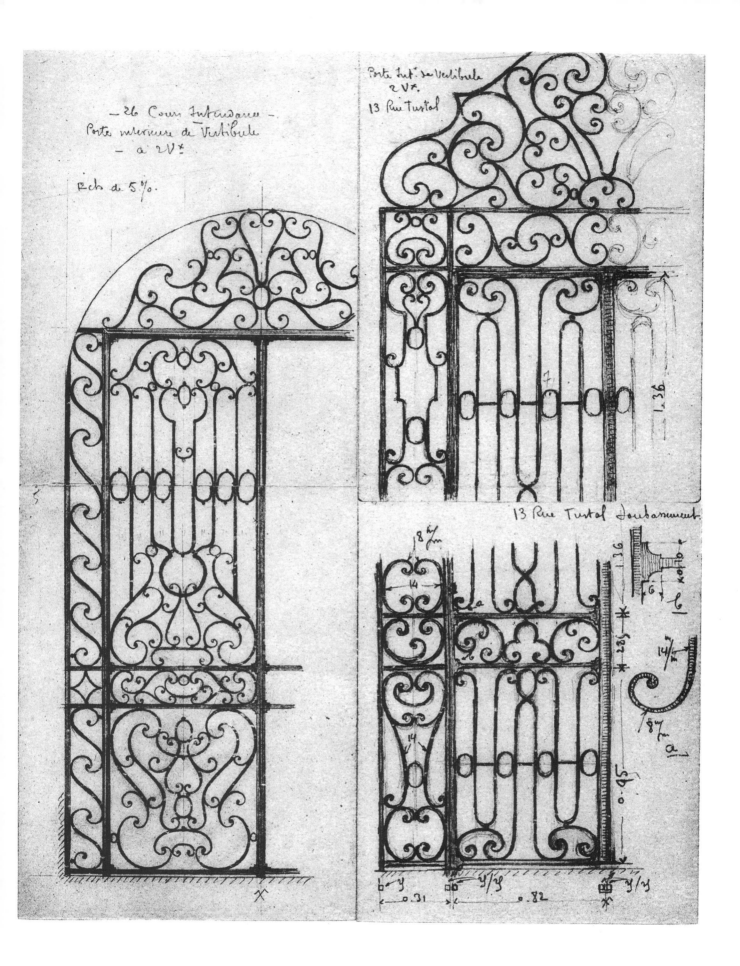

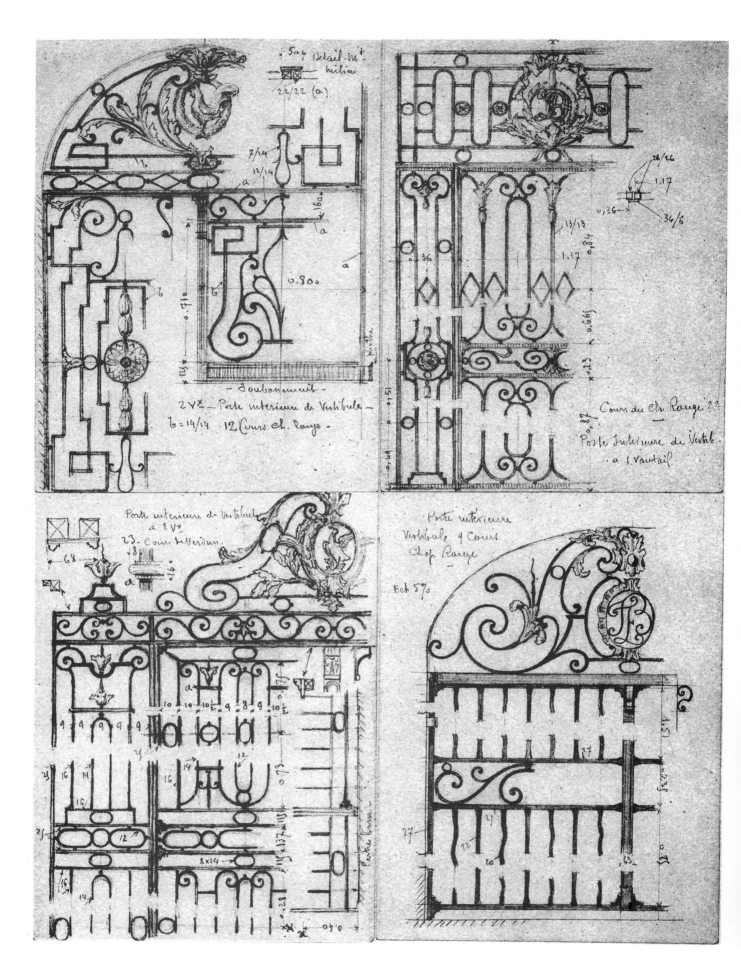

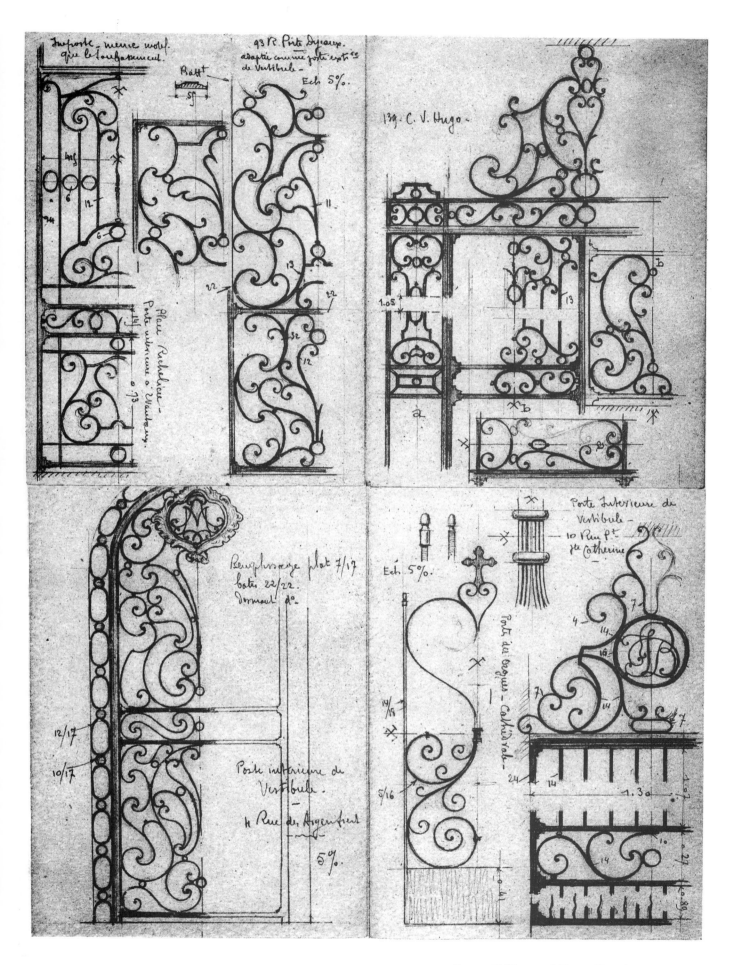

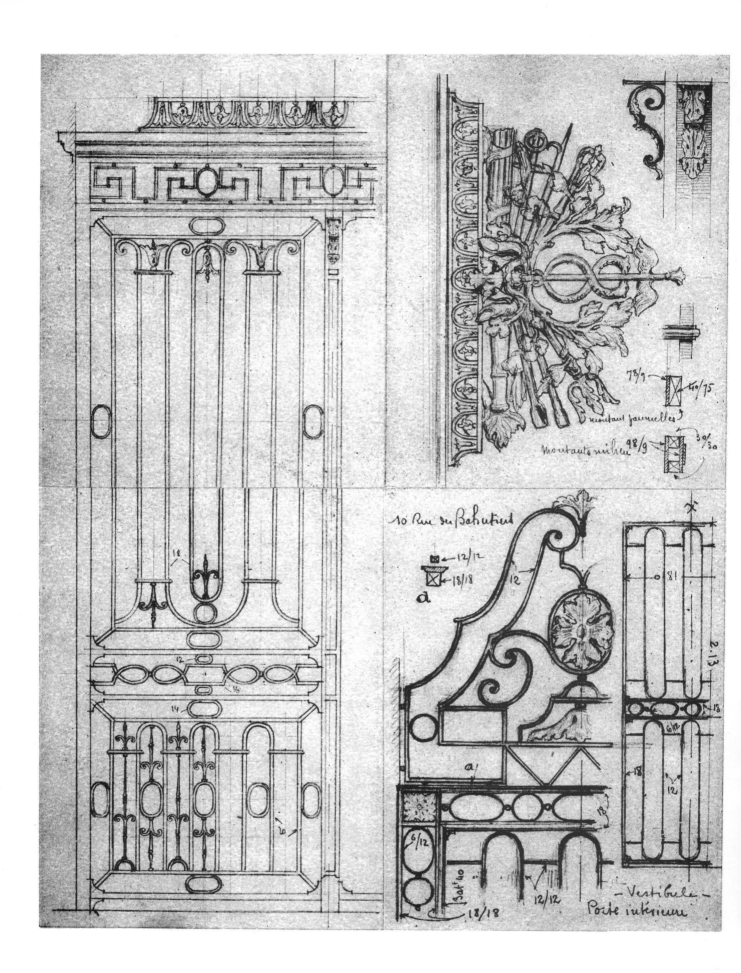

10 Rue du Bahutier

Vestibule
Porte intérieure

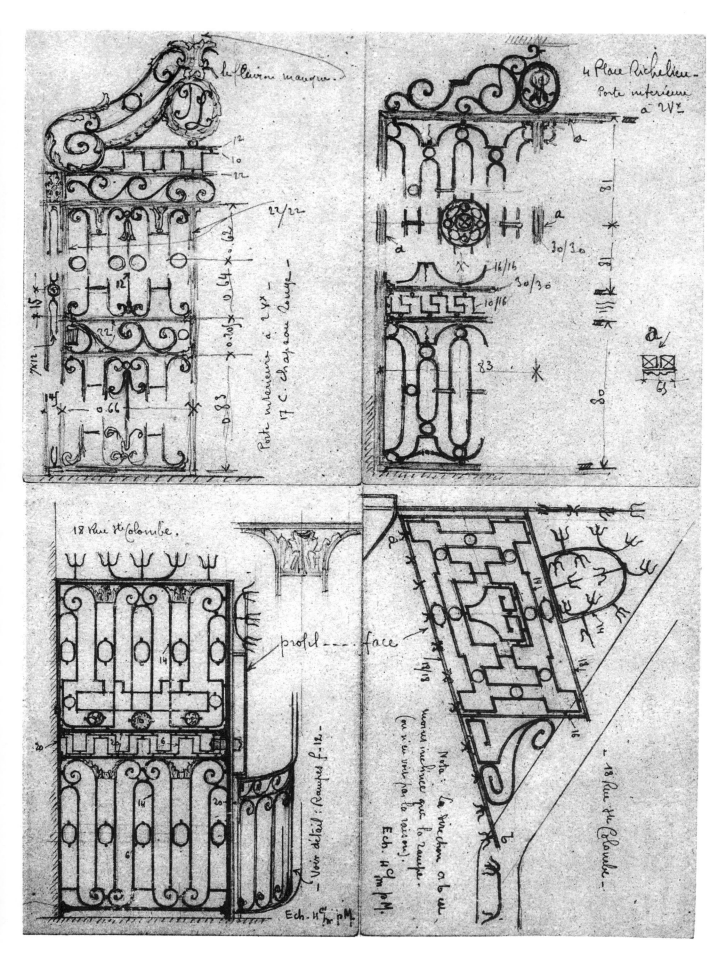

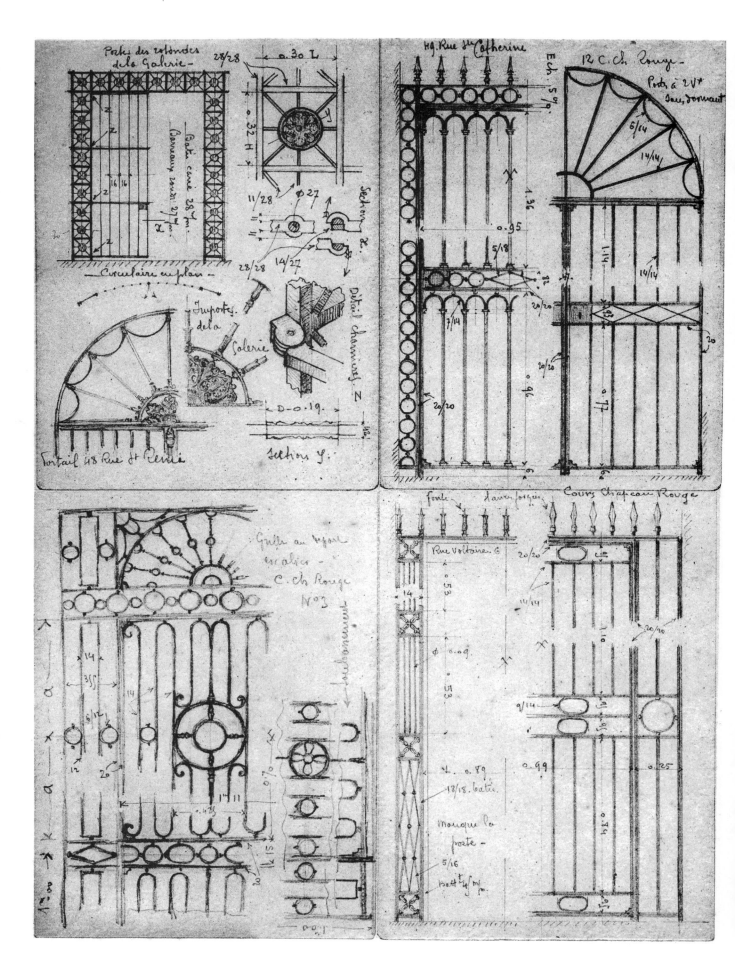

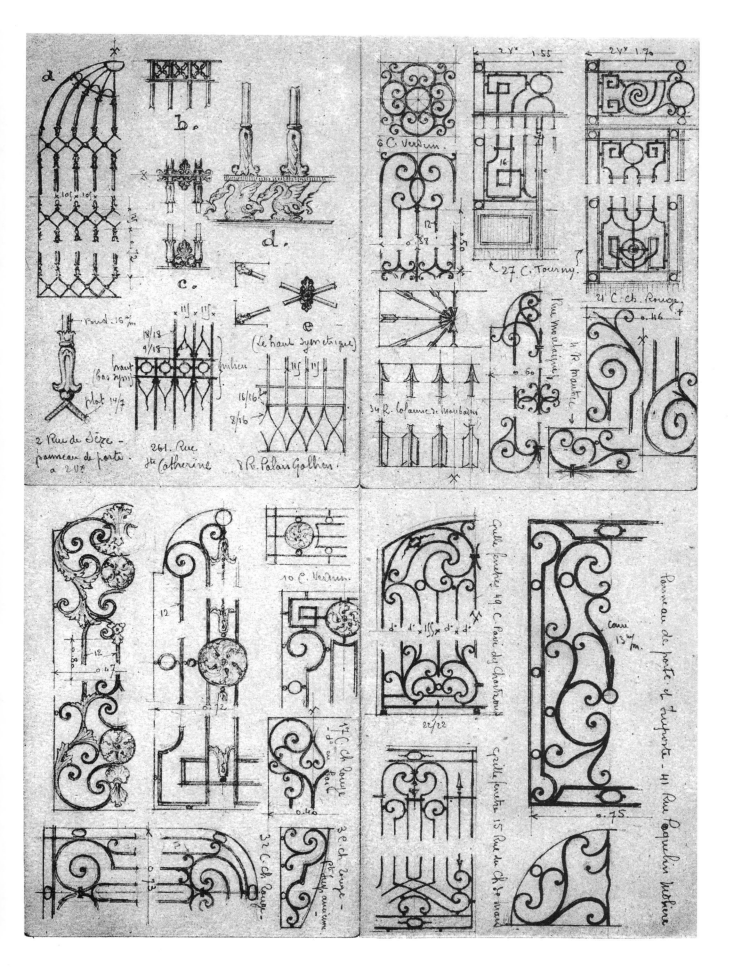

Gates, Grilles, and Door Knockers 59

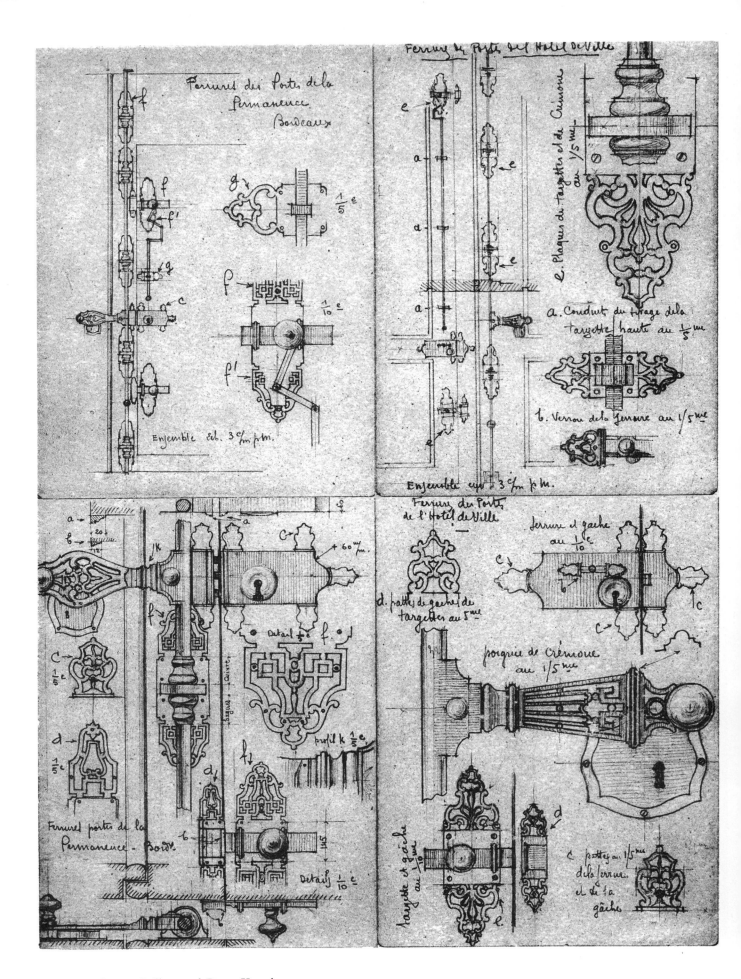

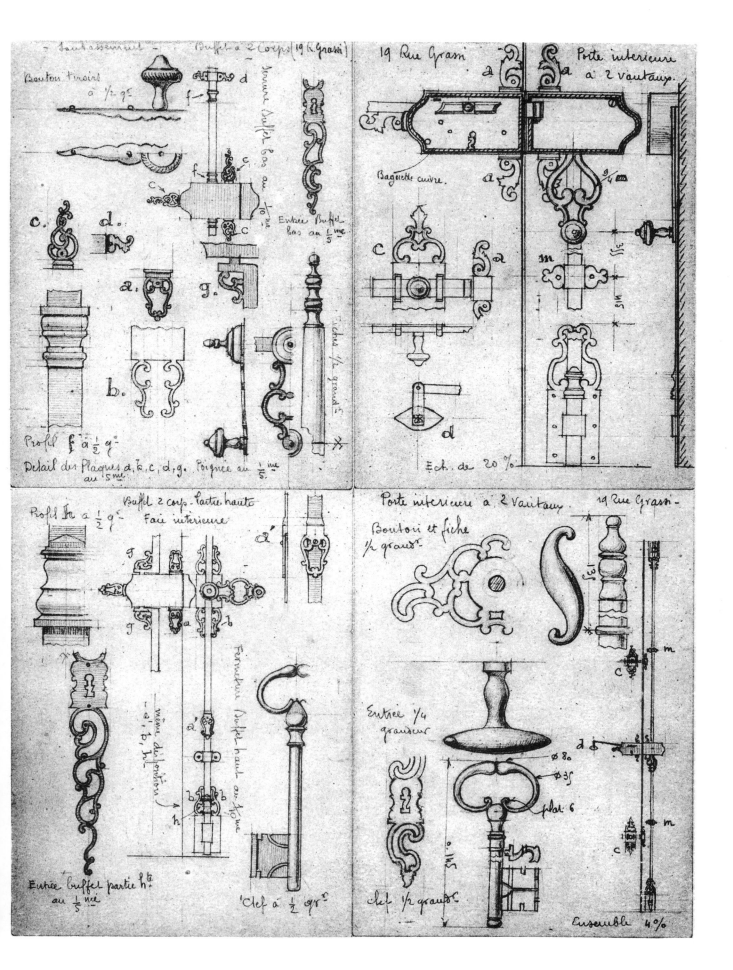

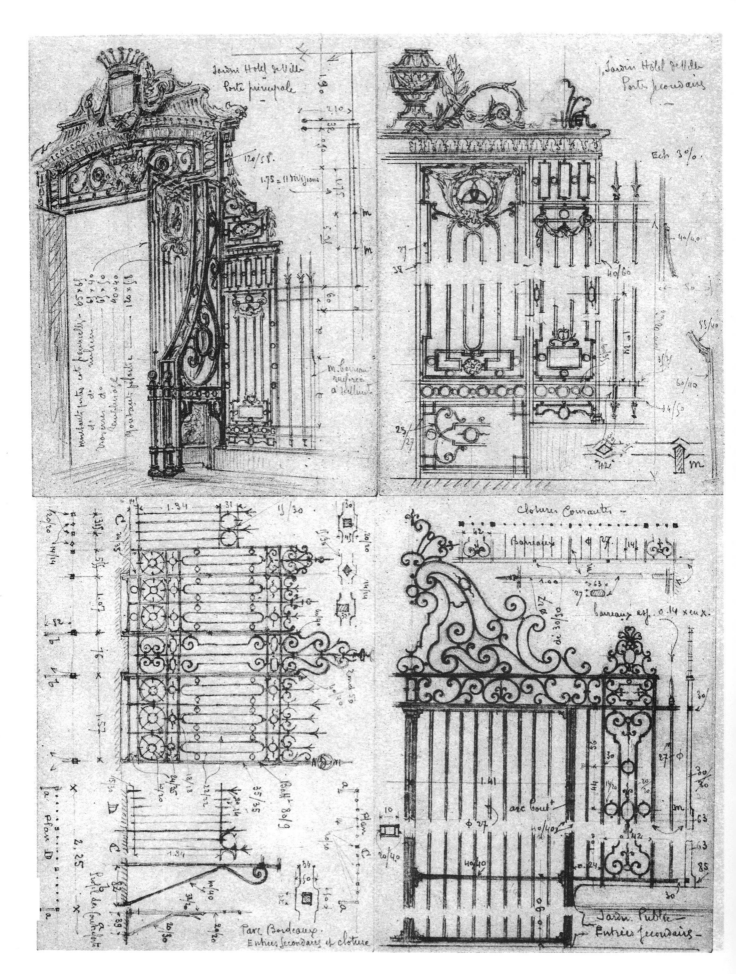

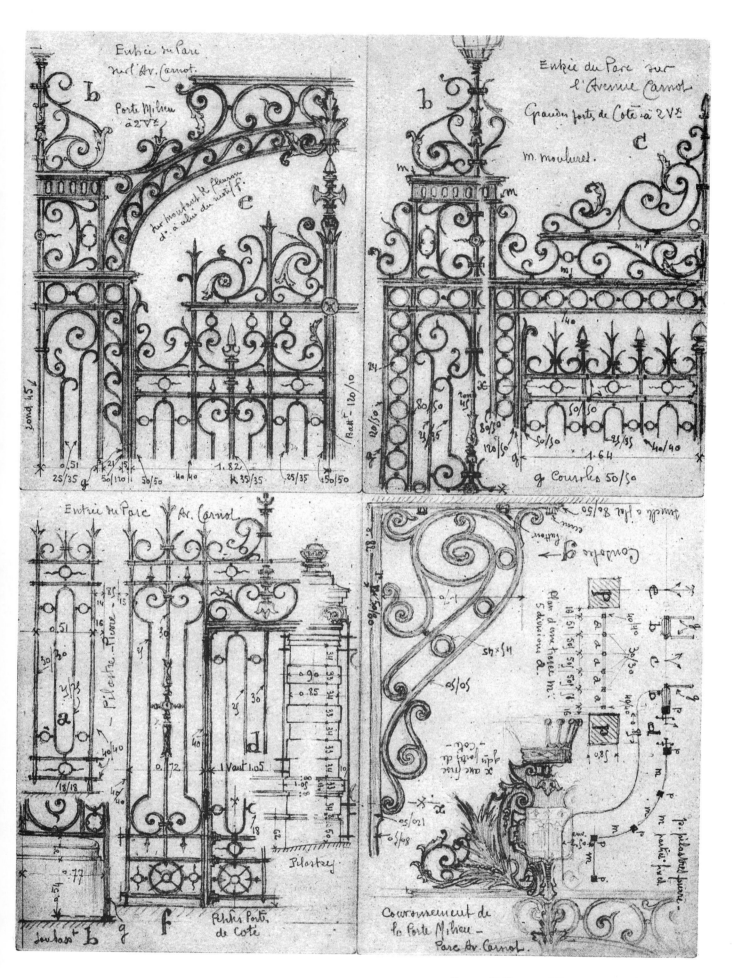

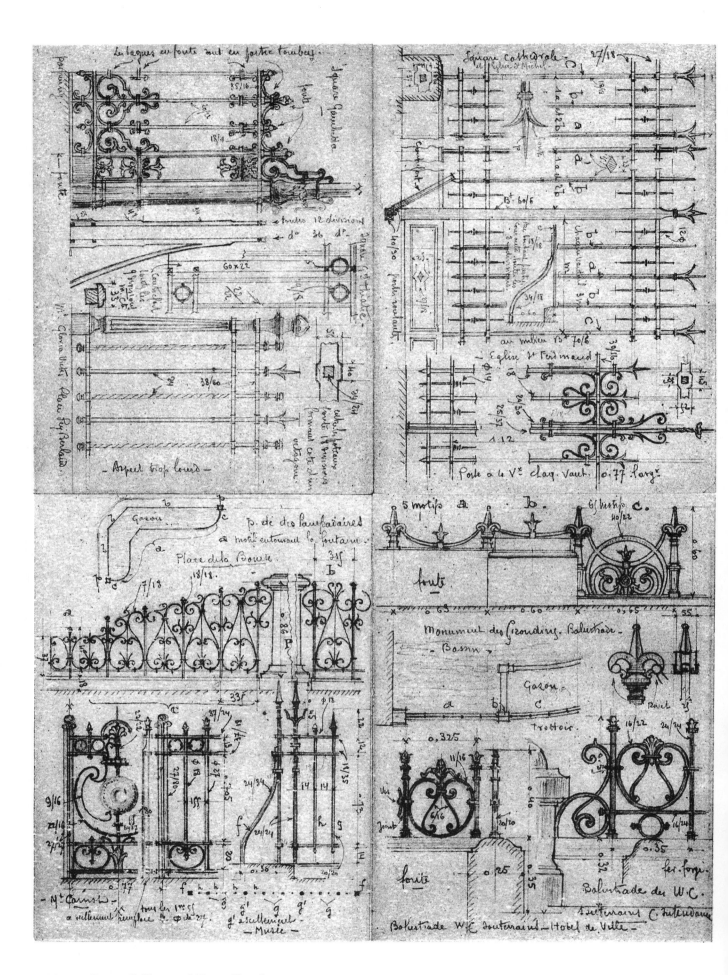

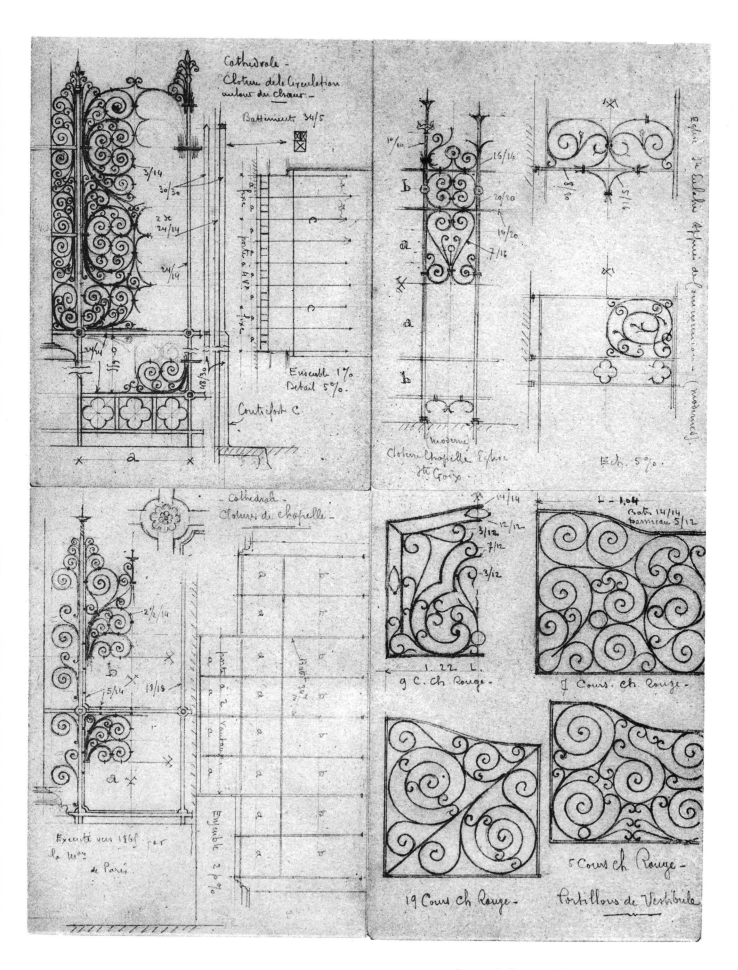

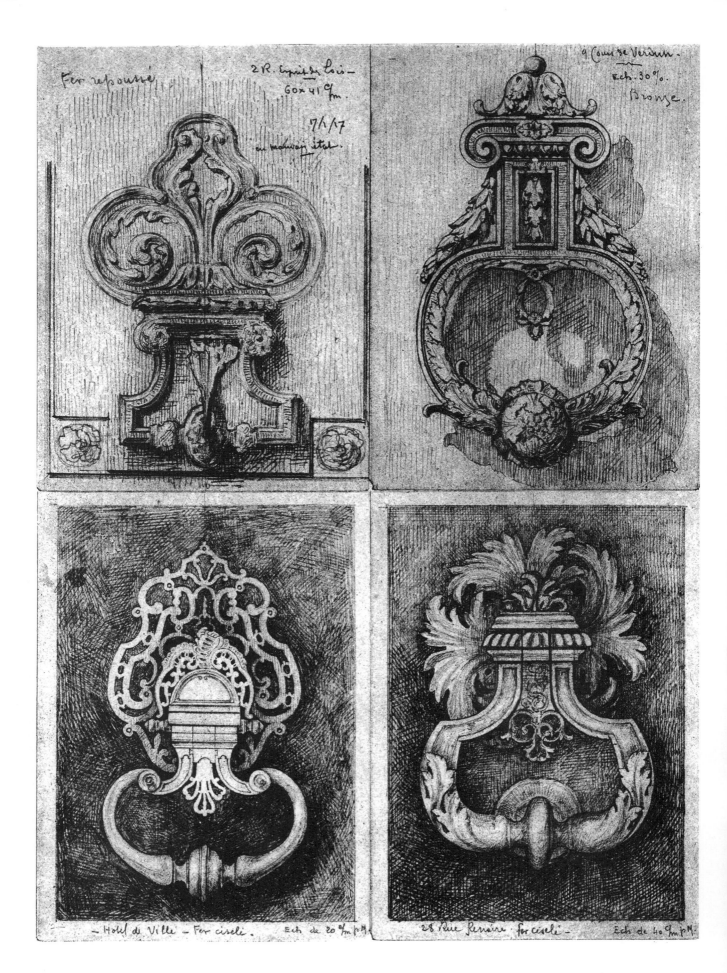

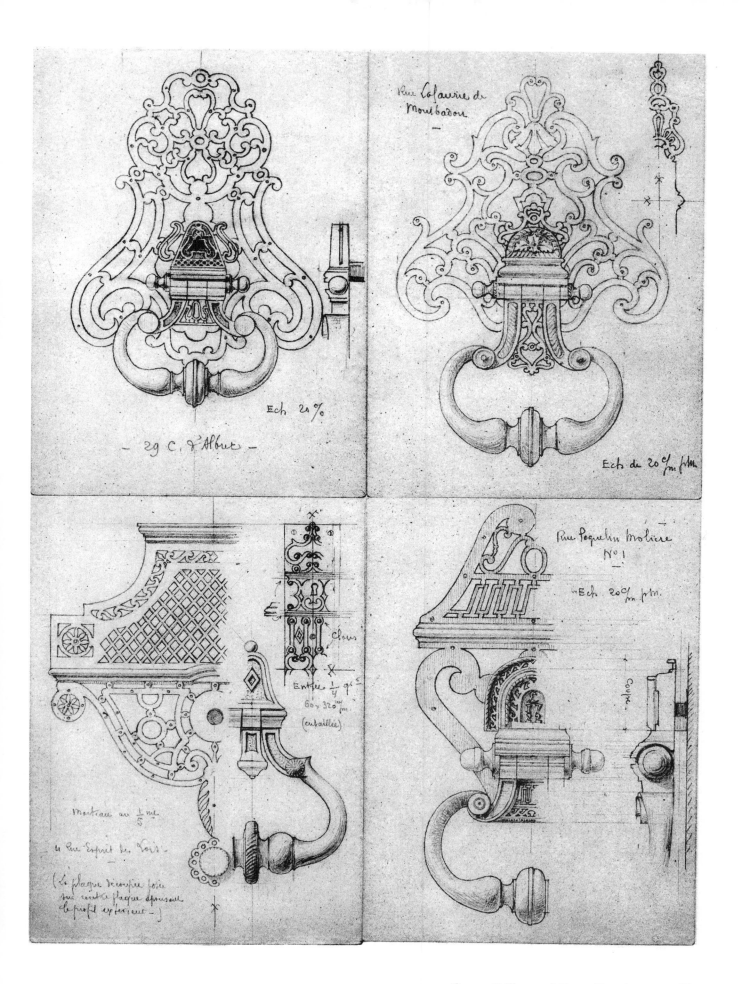

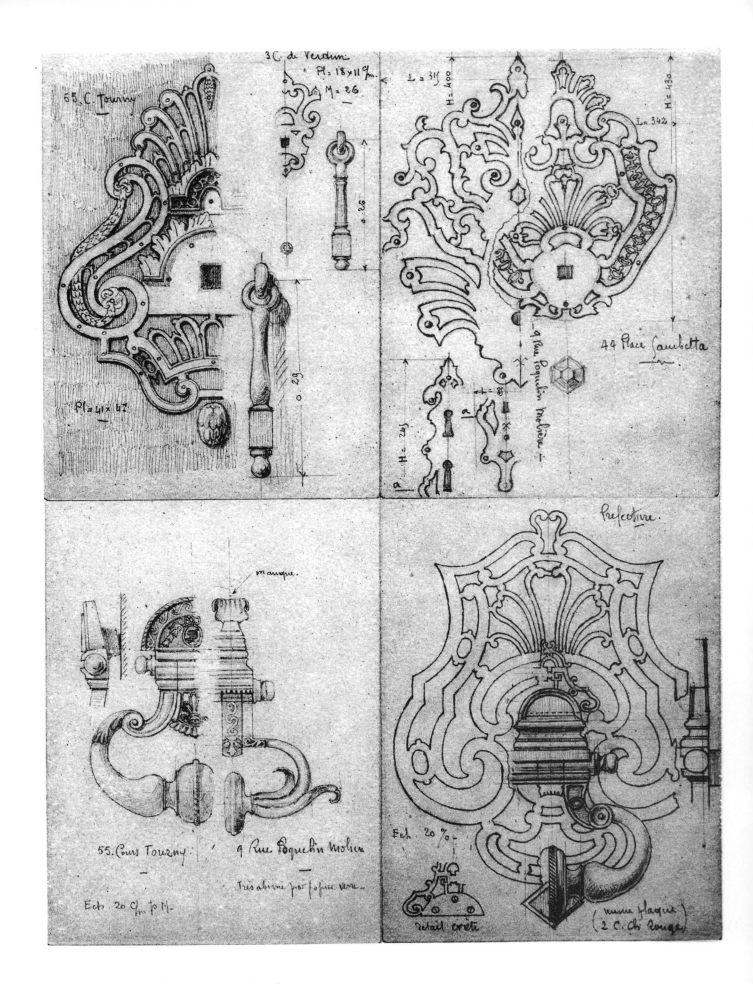

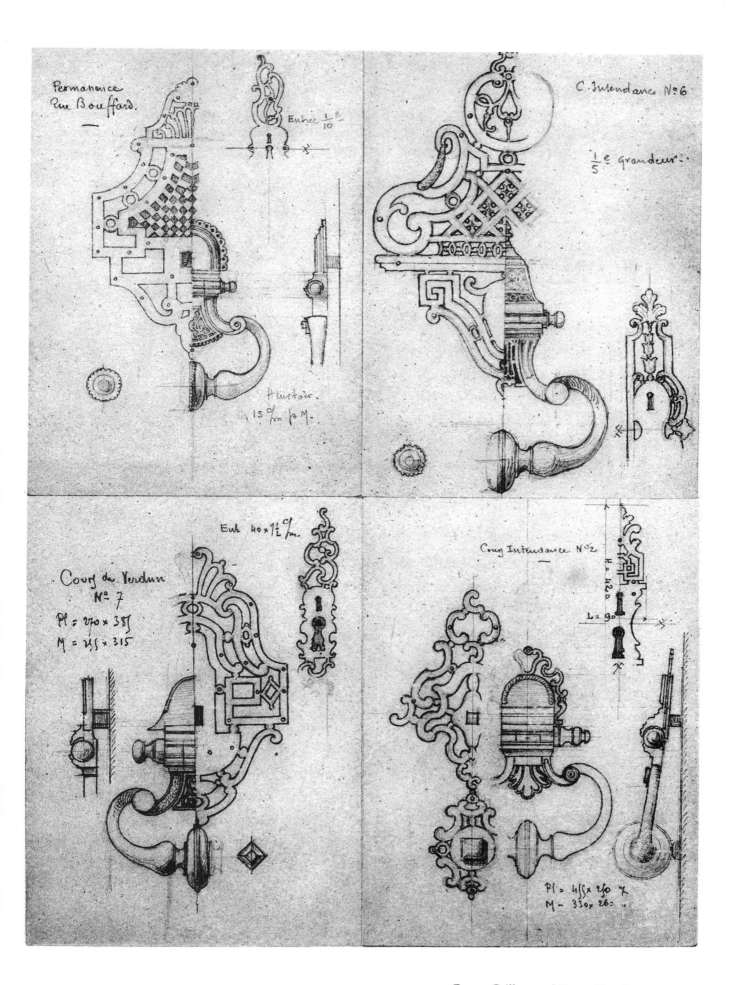

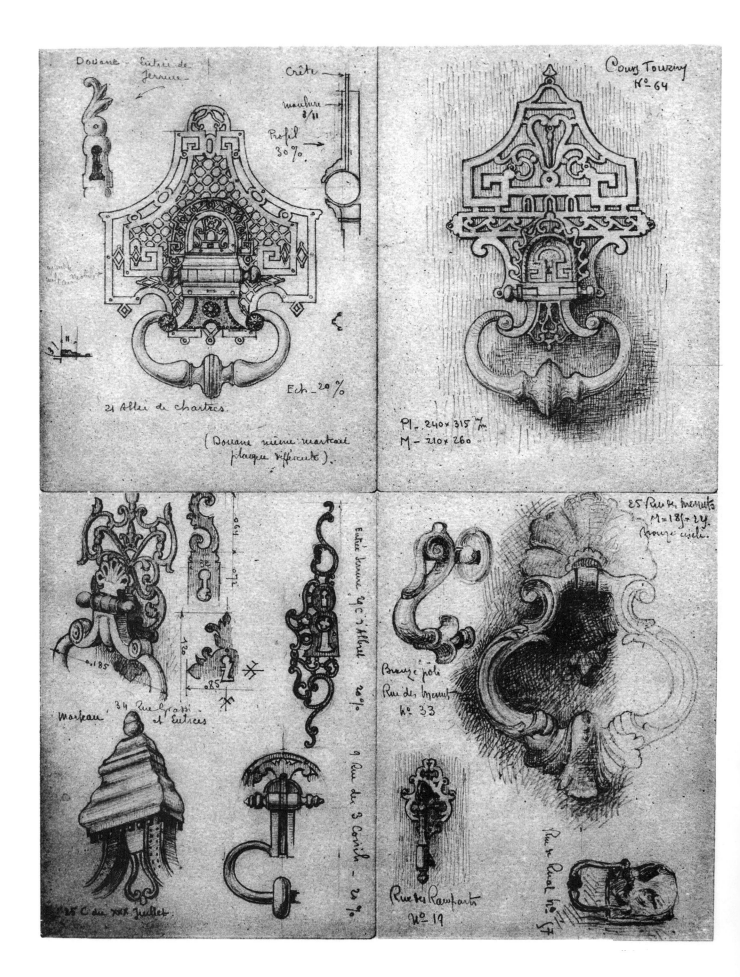

70 Gates, Grilles, and Door Knockers

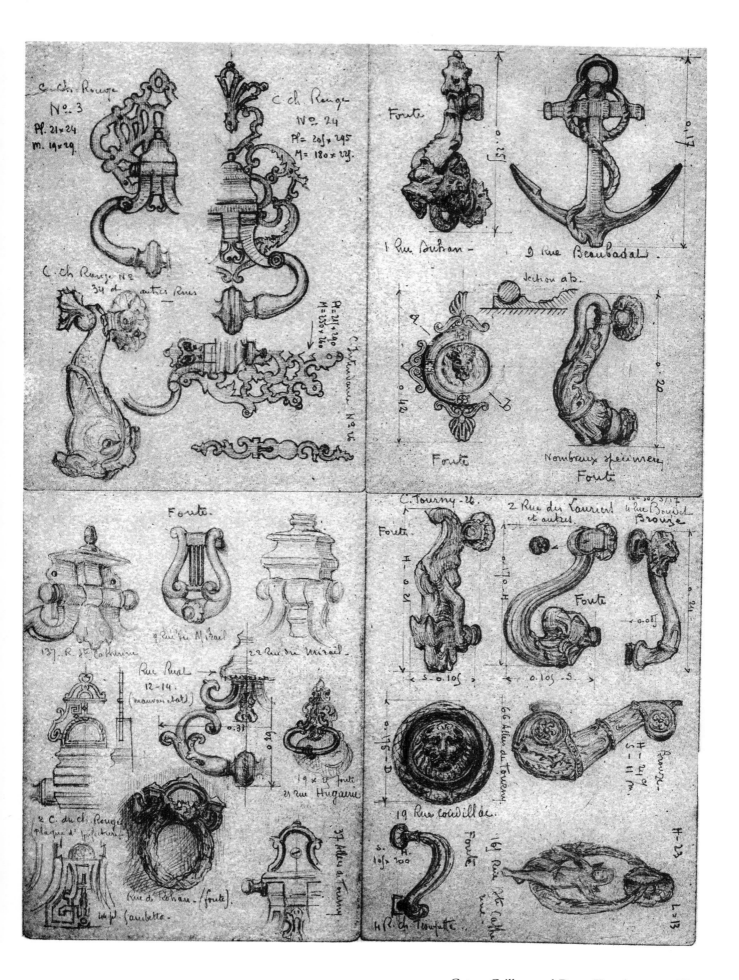

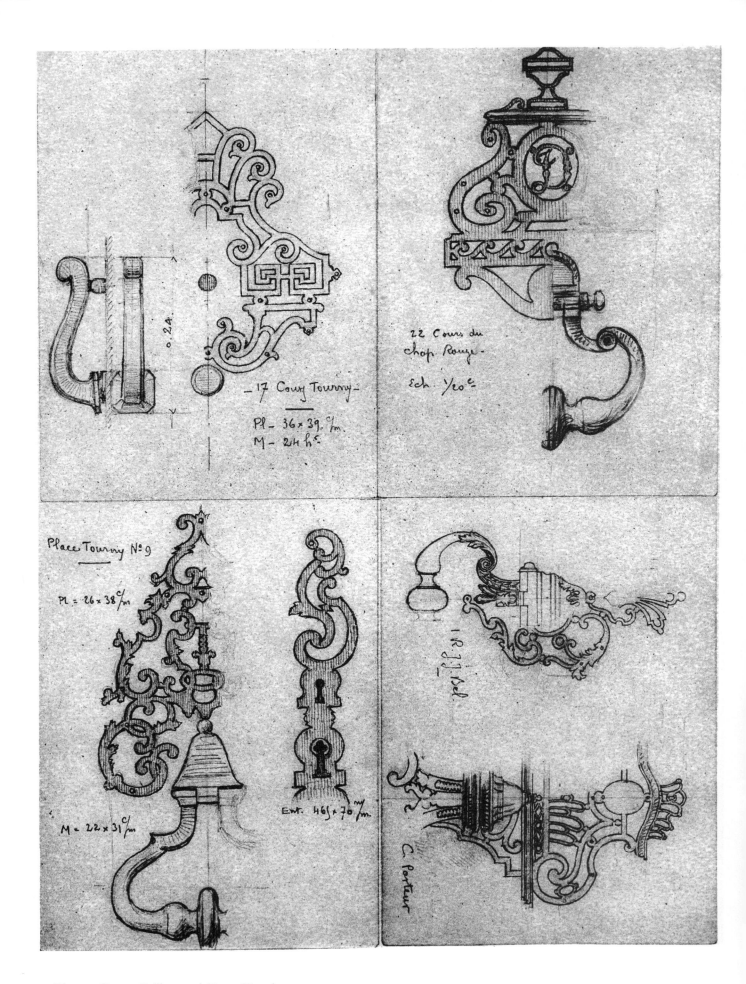

17 Cour Tourny

Pl. = 36 × 39. c/m.
M. = 24 h.s

22 Cour du
chop. Rouge.

Ech. 1/20e

Place Tourny No 9

Pl. = 26 × 38 c/m

M. = 22 × 31 c/m

Ext. 465 × 70 m/m.

C. Porteur

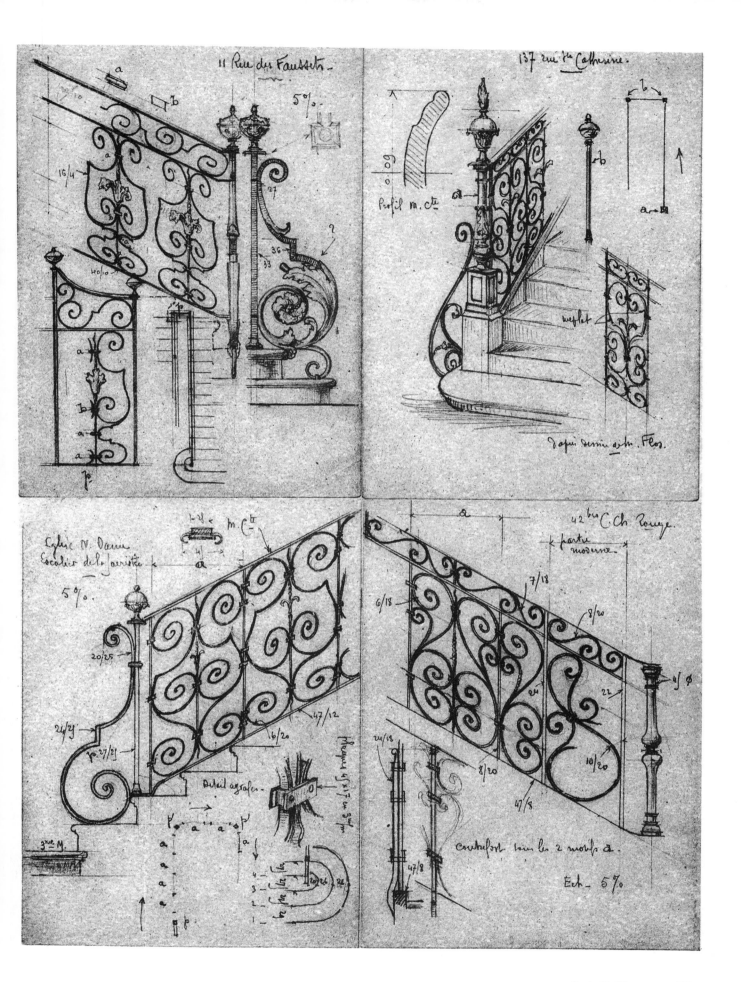

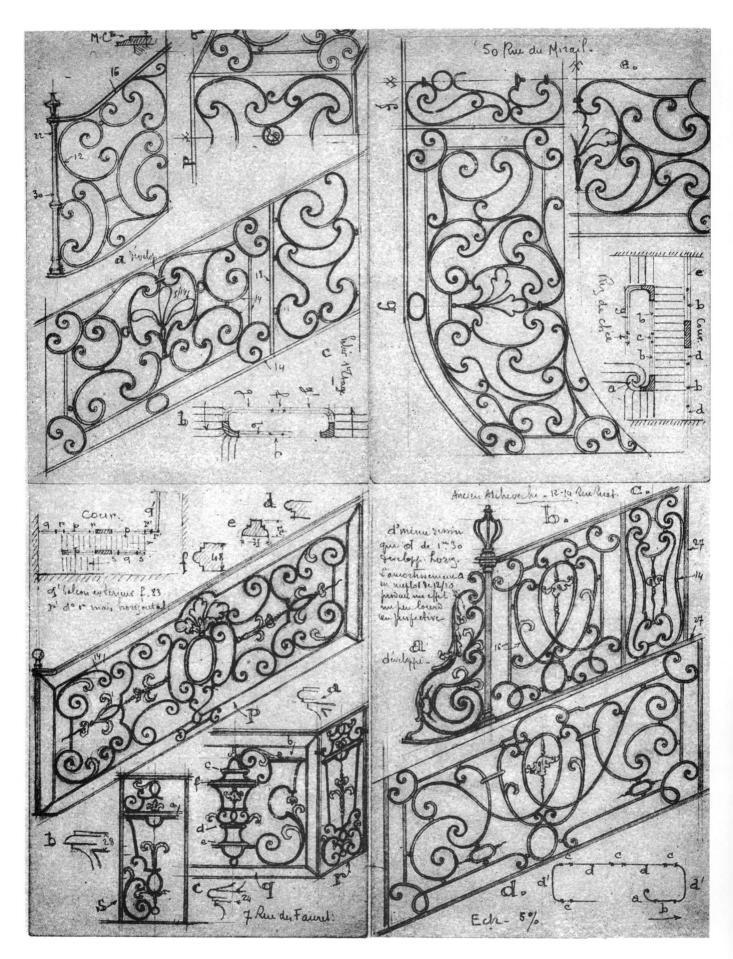

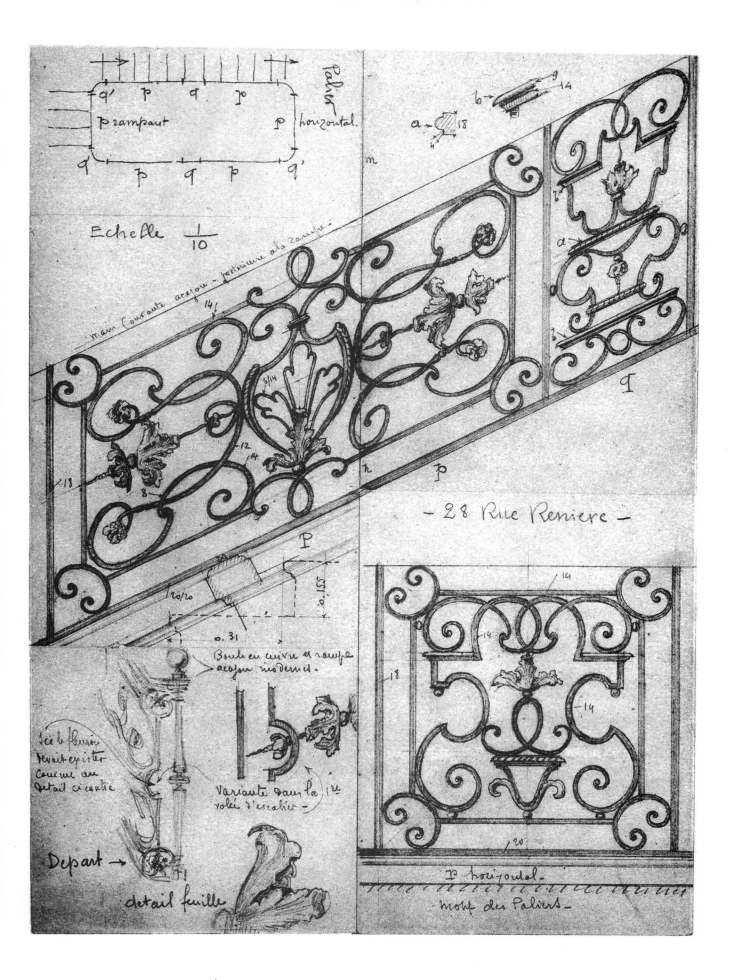

Echelle $\frac{1}{10}$

Palier

p rampant

p horizontal.

- 28 Rue Reniere -

Depart →

detail feuille

Variante dans la 1re volée d'escalier -

F horizontal.

motif des Paliers -

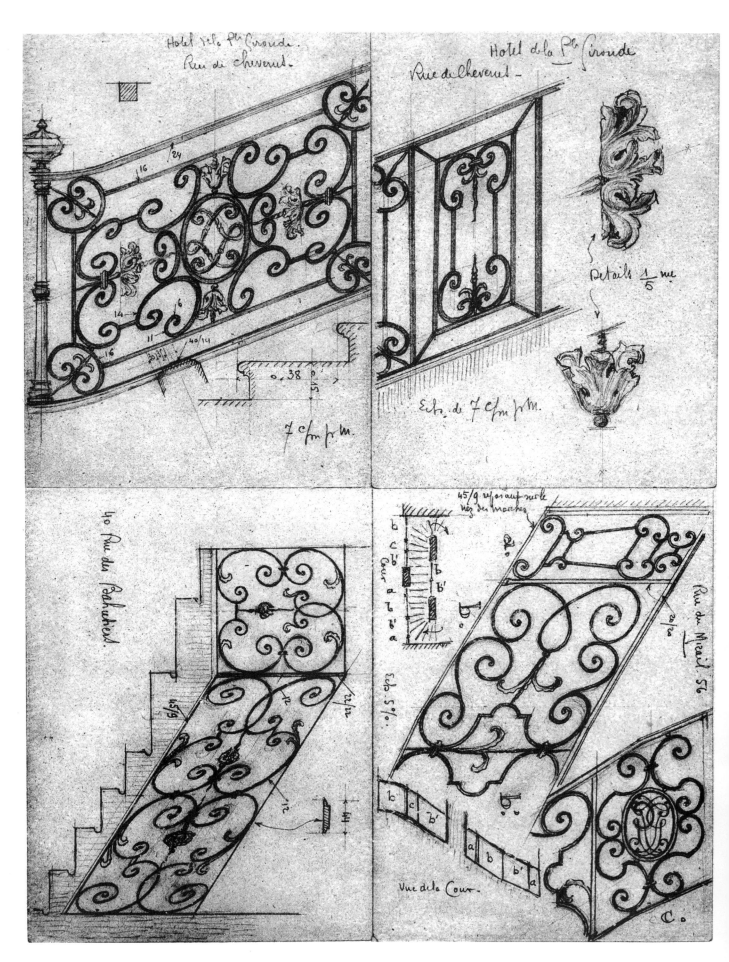

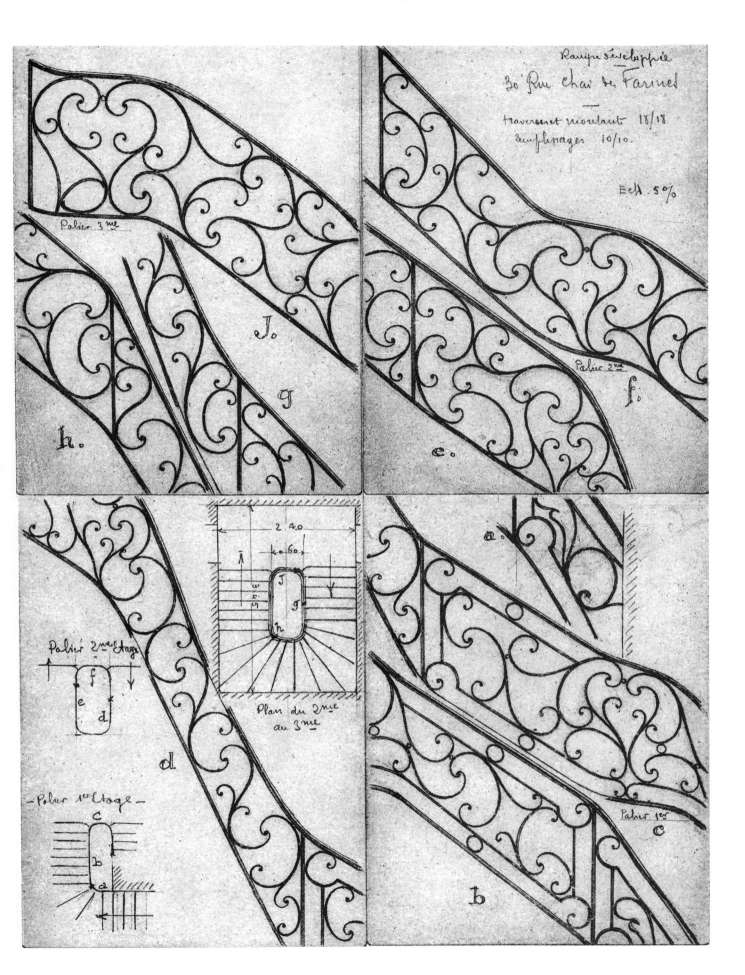

Rampe développée
30 Rue Chai de Farines
—
traversemet moulant 18/18
remplirages 10/10.

Ech . 5%

Palier 3me

J.

g

h.

Palier 2me

f.

e.

Palier 2me Etage

f
e
d

d

Plan du 2me
au 3me

2.40
0.60
3.15

J
g
h

– Palier 1er Etage –

c
b
a

a.

b

Palier 1er

c

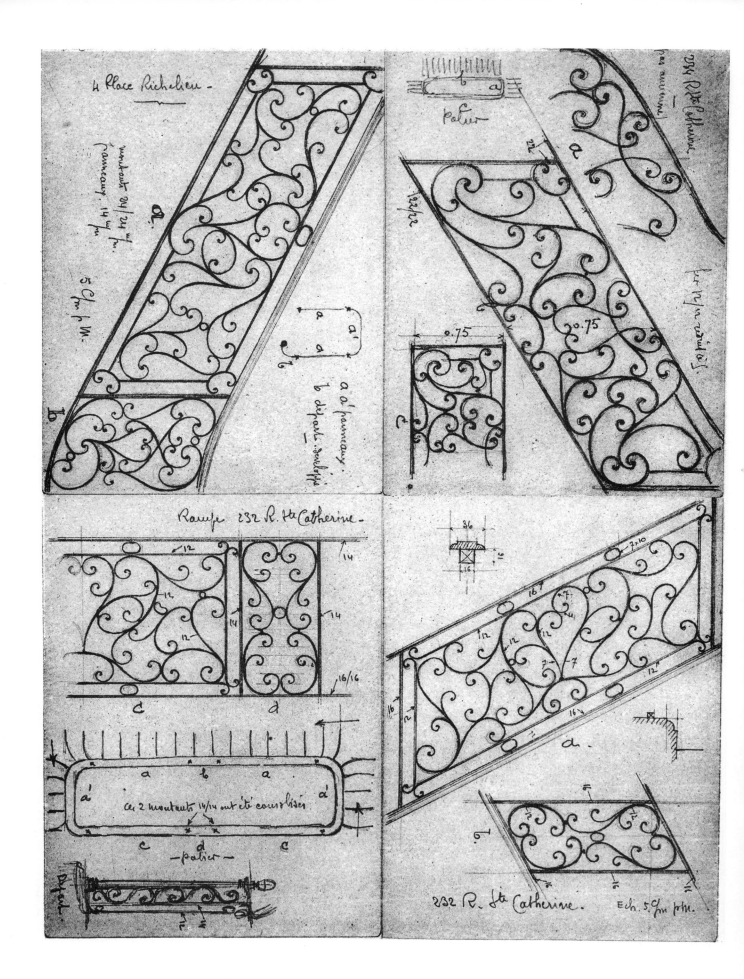

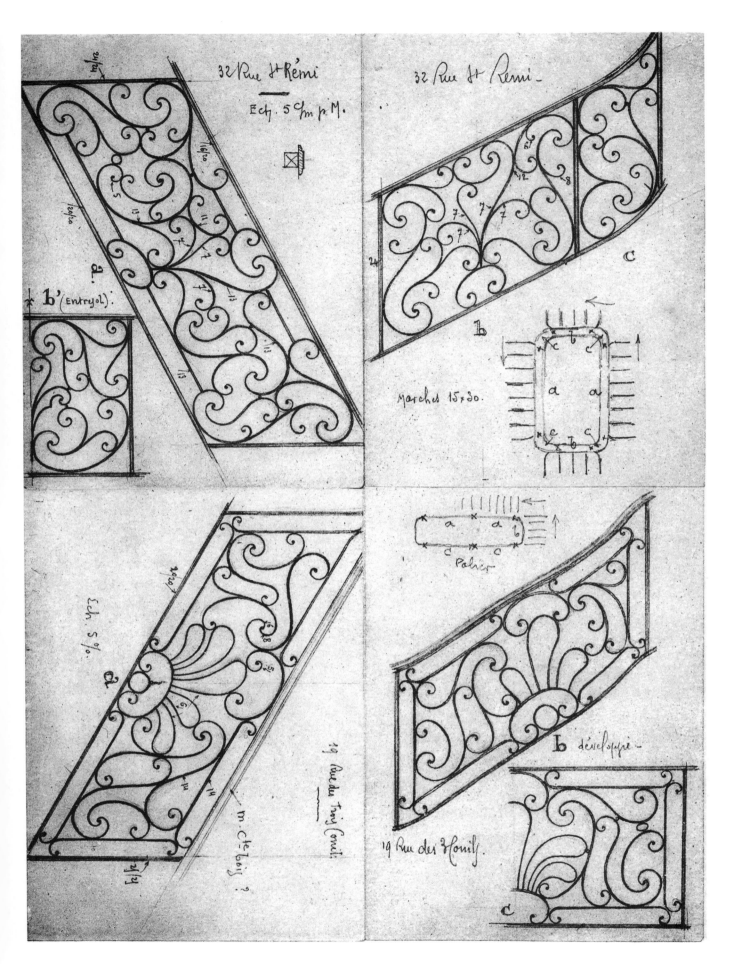

32 Rue St Rémi

Ech. 5 ⁰/ₘ p. M.

a.

b' (Entresol).

32 Rue St Rémi

c

b

Marches 15×30.

Palier

Ech. 5 %.

d

19 Rue du Tuij(onil

19 Rue des 2/Honils.

b développé

c

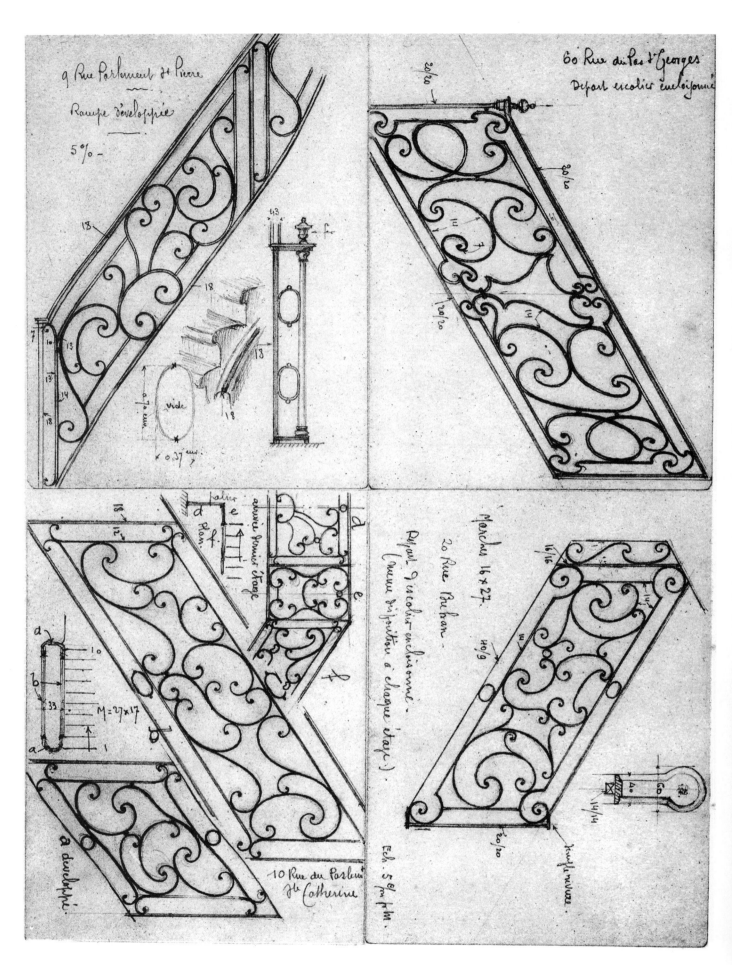

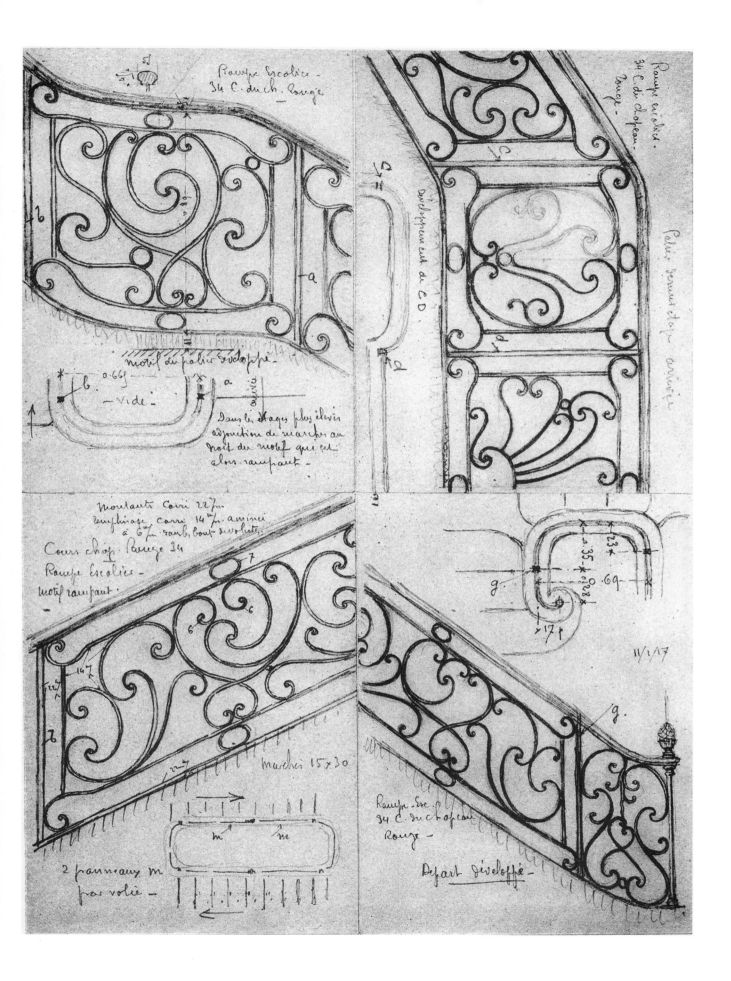

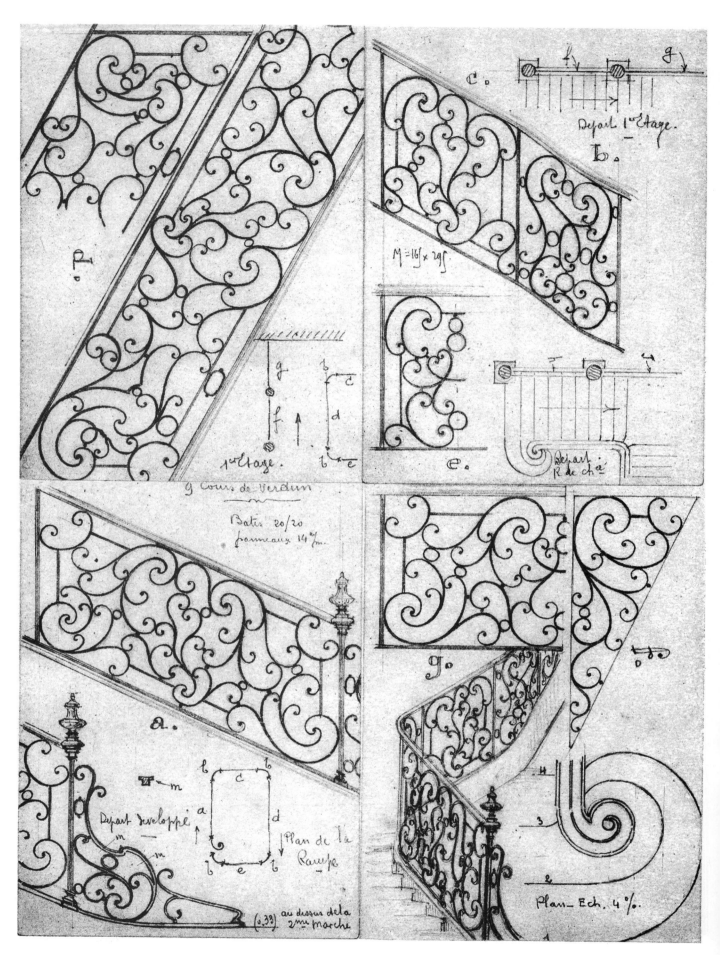

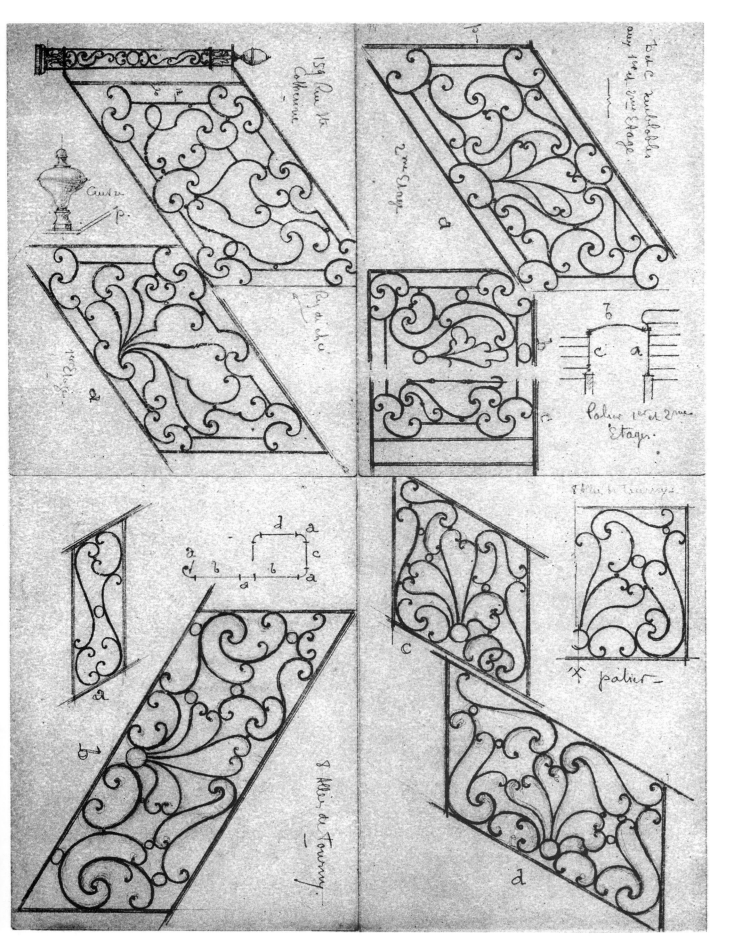

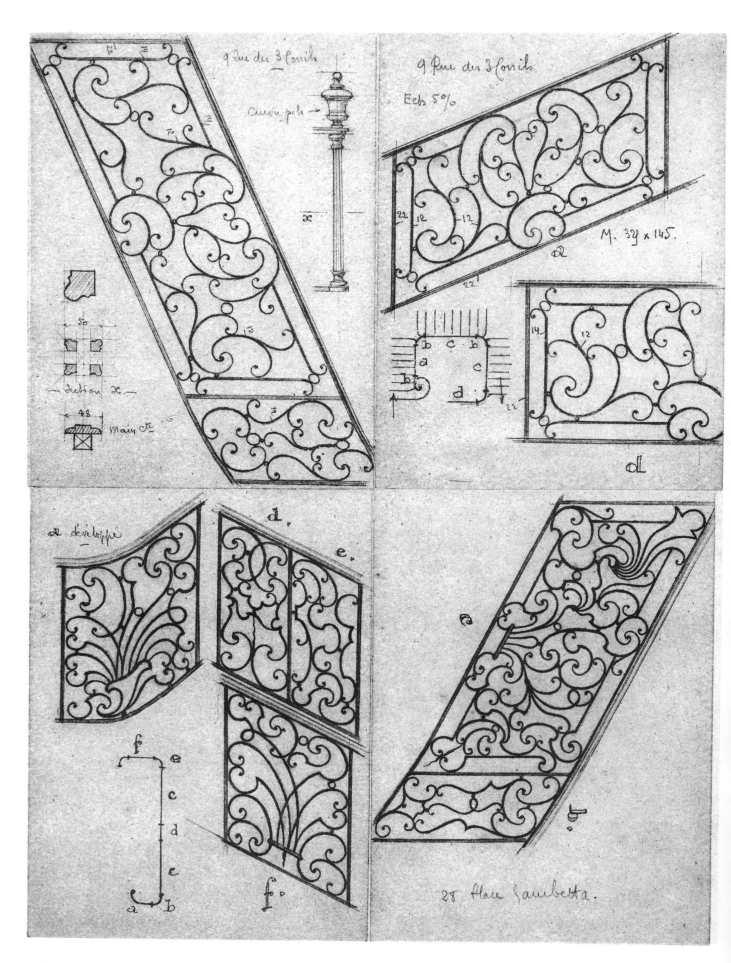

9 Rue des 3 Conils

Cuivre poli →

x

50

Section x

48 Main ct

9 Rue des 3 Conils

Ech 5%

22 12 12

M. 34 × 145.

a

22

b c b

a

c

b

d

22

14 12

d

a developpé

d.

e.

f

e

c

d

e

a b

f.

a

b.

28 Place Gambetta.

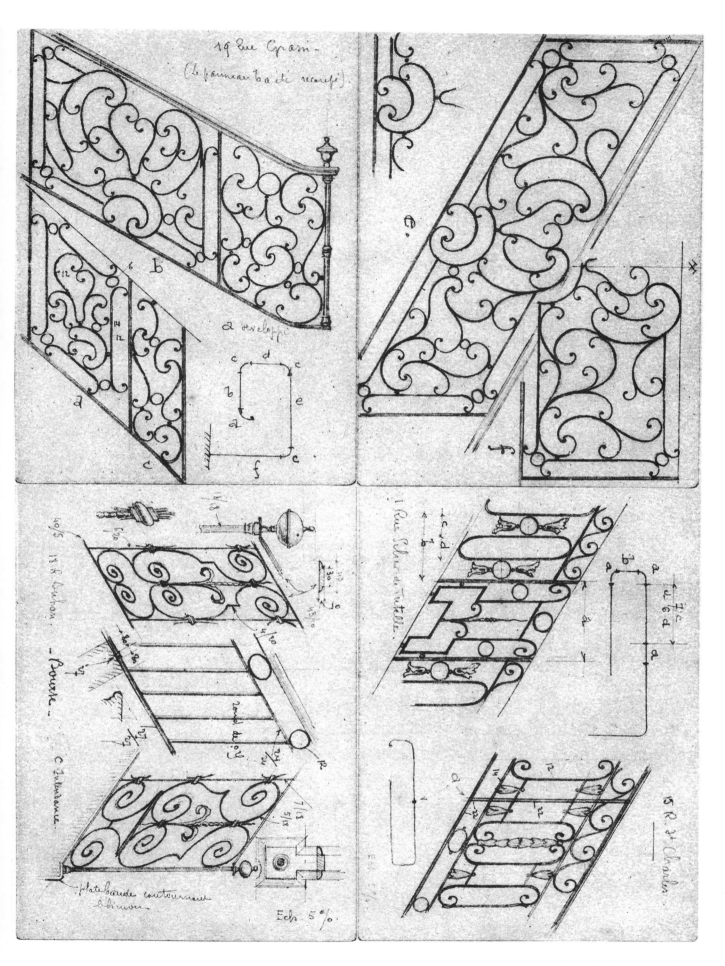

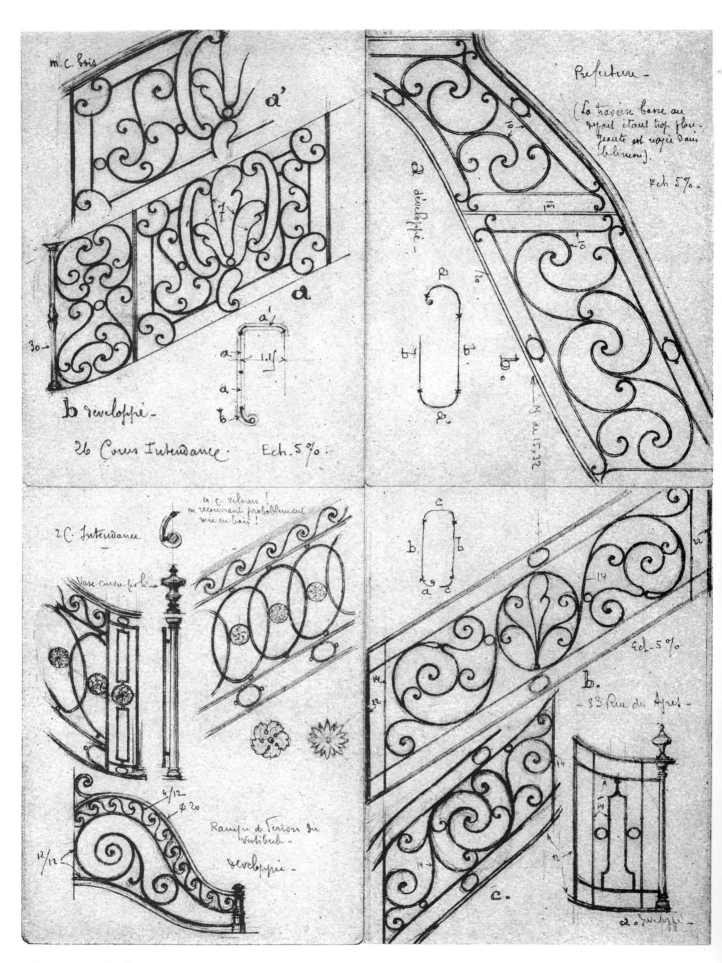

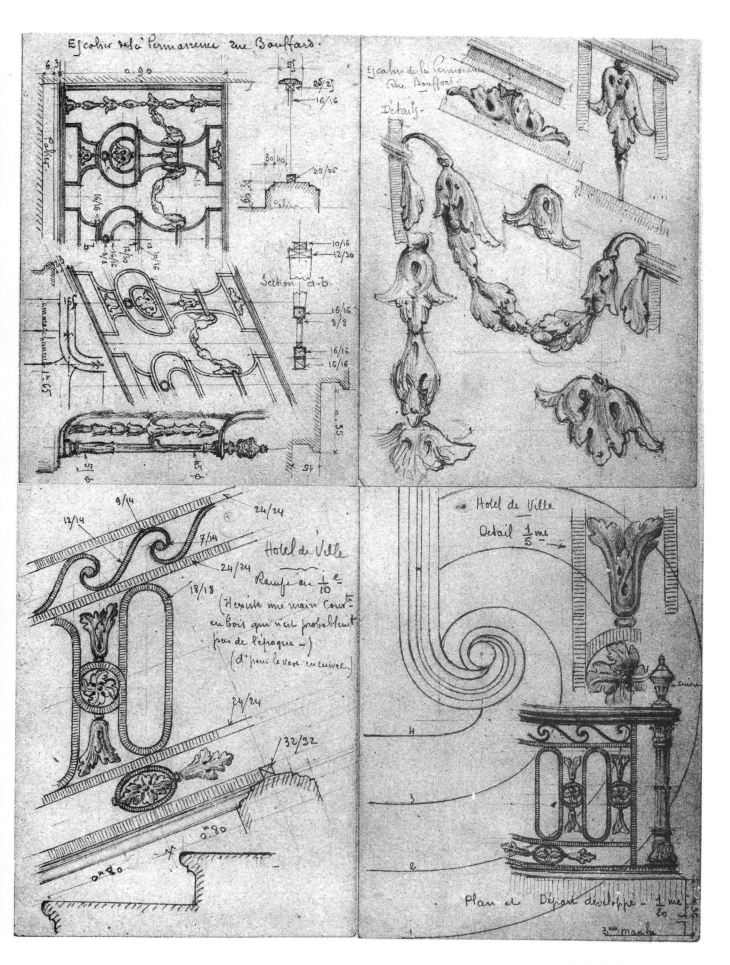

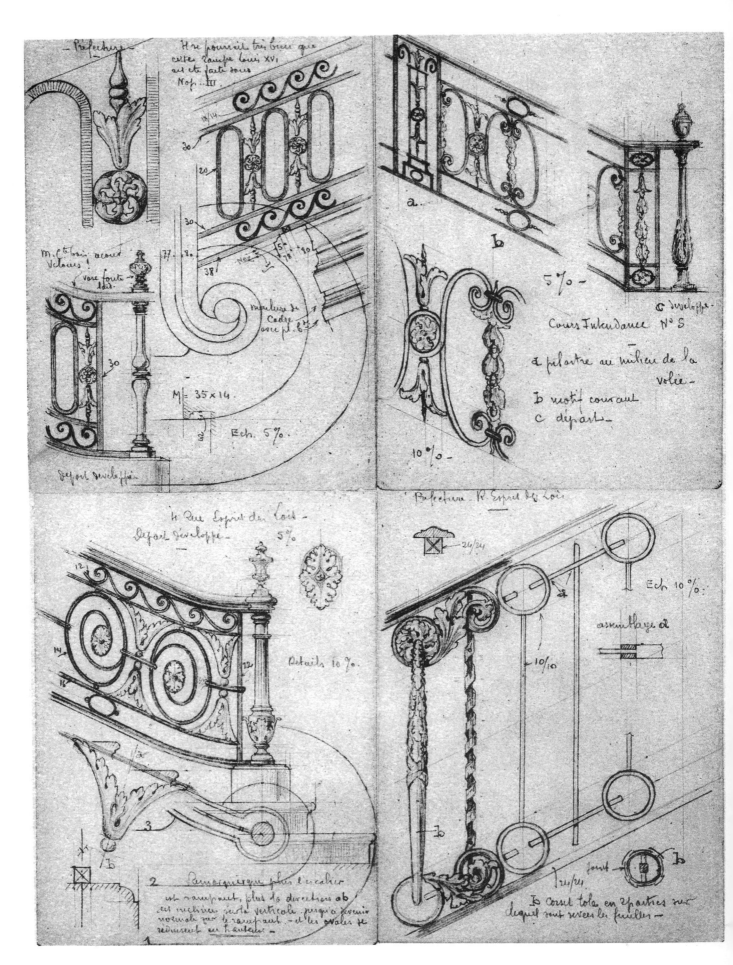

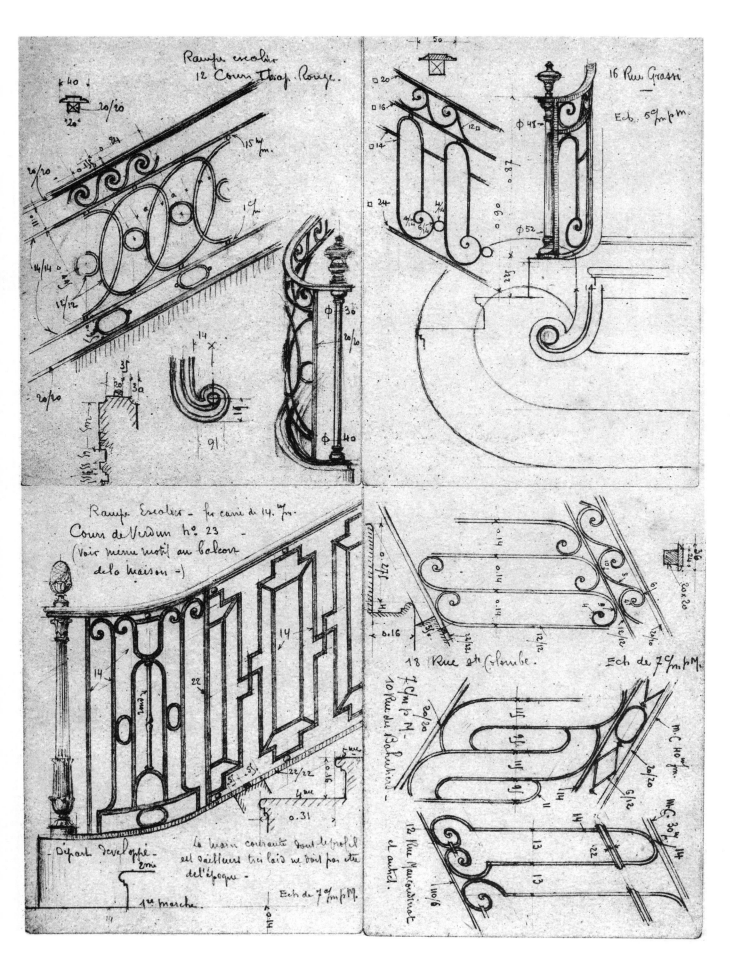

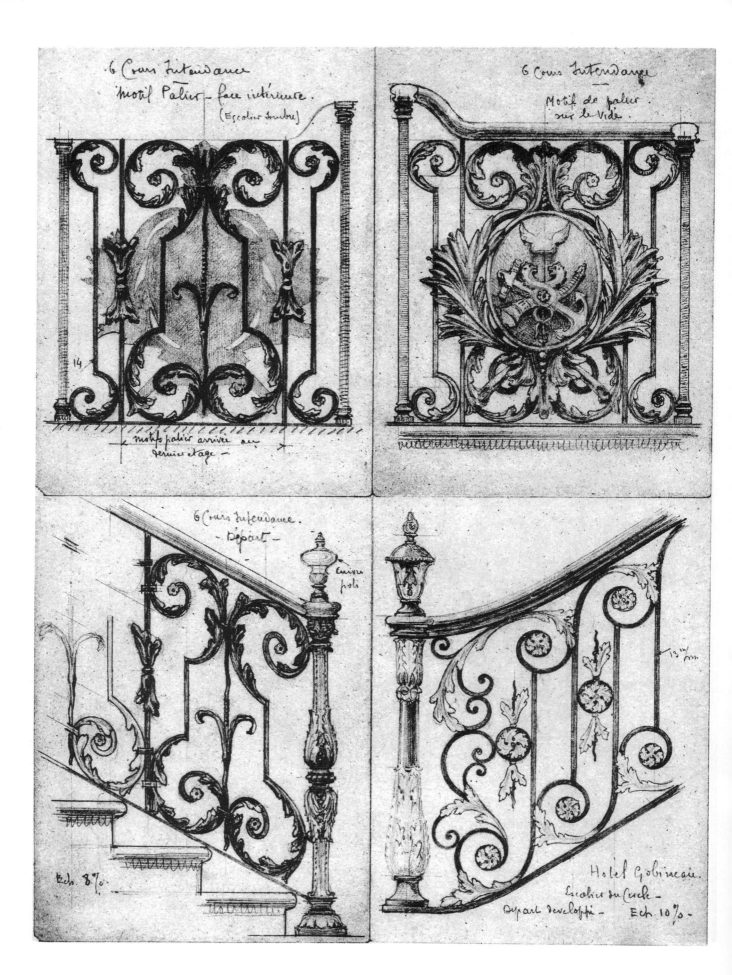

6 Cours Intendance
Motif Palier - face intérieure.
(Escalier Sombre)

14

← motifs palier arrivée au
dernier étage →

6 Cours Intendance
Motif de palier
sur le Vide.

6 Cours Intendance.
- Départ -

Cuivre
poli

Ech. 8%

13 m/m

Hôtel Gobineau.
Escalier du Cercle.
Départ développé - Ech. 10%.

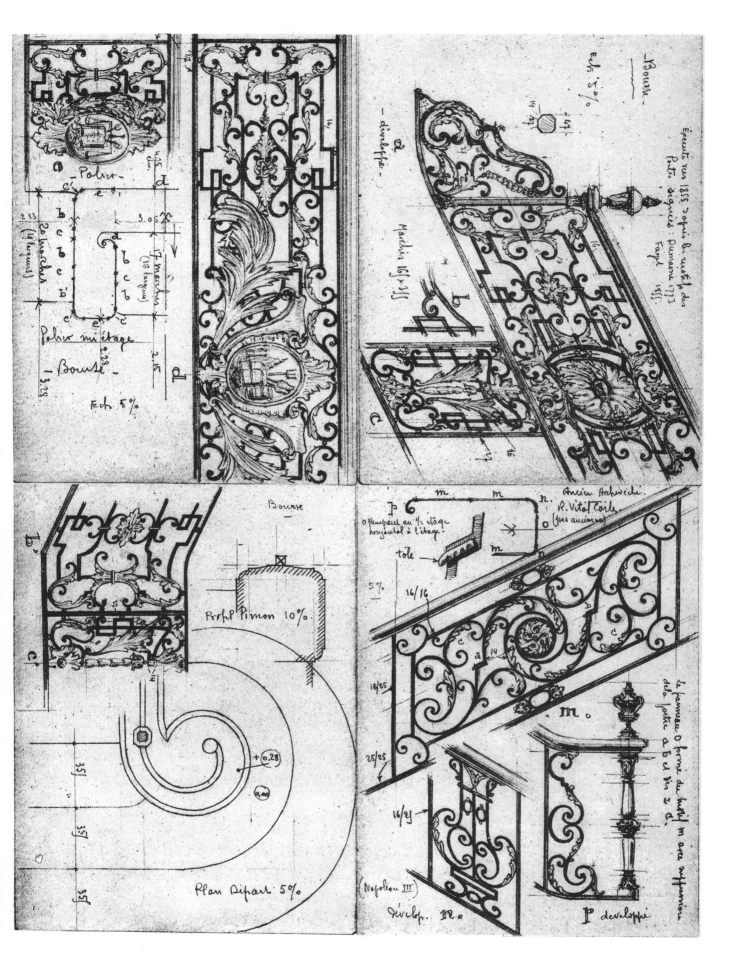